TRADITIONAL JAPANESE DESIGN MOTIFS

Joseph D'Addetta

DOVER PUBLICATIONS, INC.

NEW YORK

Publisher's Note

Through the centuries, the artists and craftsmen of Japan have elaborated a design vocabulary of remarkable sophistication and subtlety. Incorporating Chinese, Korean and Indian influences as well as native elements, traditional Japanese design has a distinctive national character that has, in turn, influenced artistic developments in the West, particularly since the nineteenth century.

The interest engendered by Joseph D'Addetta's first Dover book of original pen renderings of motifs from the kindred tradition of China (*Treasury of Chinese Design Motifs*, 1981, 24167-X) has prompted him to create the present volume. He has drawn over 200 designs from a wide range of *objets d'art* from leading museums and private collections. Ceramics and textiles yielded the largest number of motifs, but designs from lacquerware, screens, fans, wood carvings, theatrical costumes and masks, sword cases and guards, ink drawings and woodblock prints are represented as well. The earliest motif in this compendium dates from the thirteenth century, but designs of the seventeenth, eighteenth and nineteenth centuries preponderate. There are also scattered examples of twentieth-century work.

The plates are arranged according to the following categories (based on the main motif of the plate): Plants and Flowers (Plates 1–46), Animal Life (47–60), Human Figures (61–68; including some deities or demons), Symbolic Objects (69–70), Geometric Patterns (71–76), Water and Wave Forms (77–87) and fully rendered Ceramic Objects (88–90). In the captions, the use of Japanese terms has been kept to a minimum. Dating of motifs, where available, is expressed in Western centuries unless the Japanese period specified in D'Addetta's source spans more than one Western century and there is no information to place the design in one Western century or another. Whenever a Japanese period is mentioned, the corresponding Western dates (in round numbers) are given in parentheses. Motifs from ceramic objects are usually, but not always, identified by the "school." Such terms as Arita, Kutani, Nabeshima, Ninsei and Shibuemon refer to styles or centers of production, and derive either from personal names of founders of potteries or from names of localities.

Today's artists, designers and craftspeople in many disciplines will find the material in this book a rich source of inspiration. D'Addetta's clear, crisp line renderings are eminently reproducible. As part of the Dover Pictorial Archive Series, the contents are copyright-free and ready to use.

Traditional Japanese Design Motifs is a new work, first published by Dover Publications, Inc., in 1984.

DOVER *Pictorial Archive* SERIES

This book belongs to the Dover Pictorial Archive Series. You may use the designs and illustrations for graphics and crafts applications, free and without special permission, provided that you include no more than ten in the same publication or project. (For permission for additional use, please write to Dover Publications, Inc., 31 East 2nd Street, Mineola, N.Y. 11501.)

Republication or reproduction of any illustrations by any other graphics service in any book or in any other design resource is strictly prohibited.

Manufactured in the United States of America
Dover Publications, Inc., 31 East 2nd Street, Mineola, N.Y. 11501

Library of Congress Cataloging in Publication Data

D'Addetta, Joseph.
 Traditional Japanese design motifs.

 (Dover pictorial archive series)
 1. Decoration and ornament—Japan—Themes, motives.
I. Title. II. Series.
NK1484.A1D3 1984 745.4′4952 83-20583
ISBN 0-486-24629-9

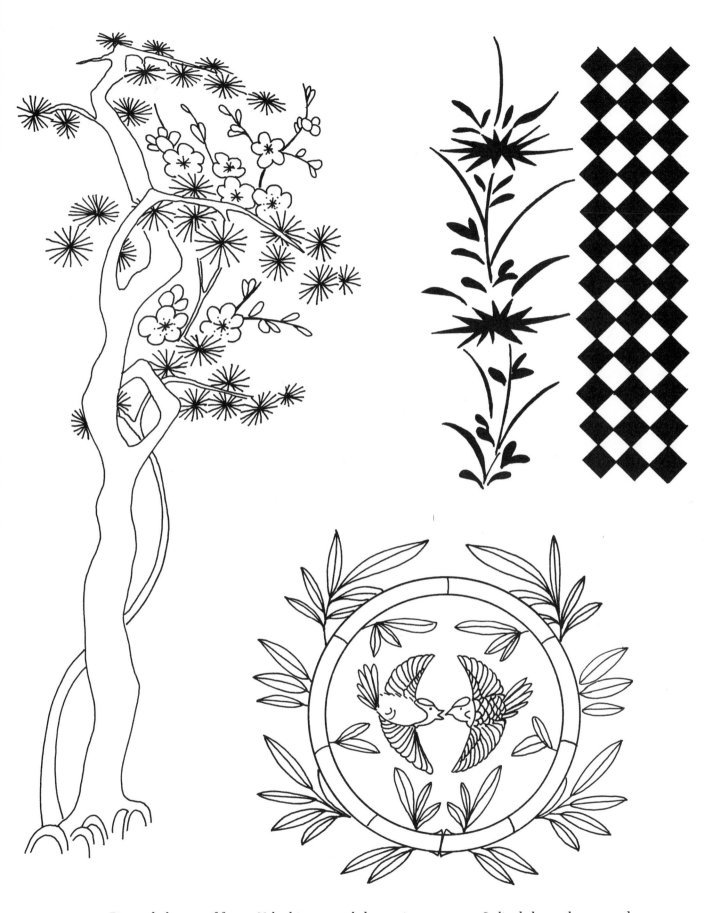

LEFT: Pine and plum motif from a Nabeshima enameled ceramic. TOP RIGHT: Stylized chrysanthemum and rhombus design from a 20th-century ceramic. BOTTOM RIGHT: Bamboo and sparrow motif from a 17th-century leather sword case.

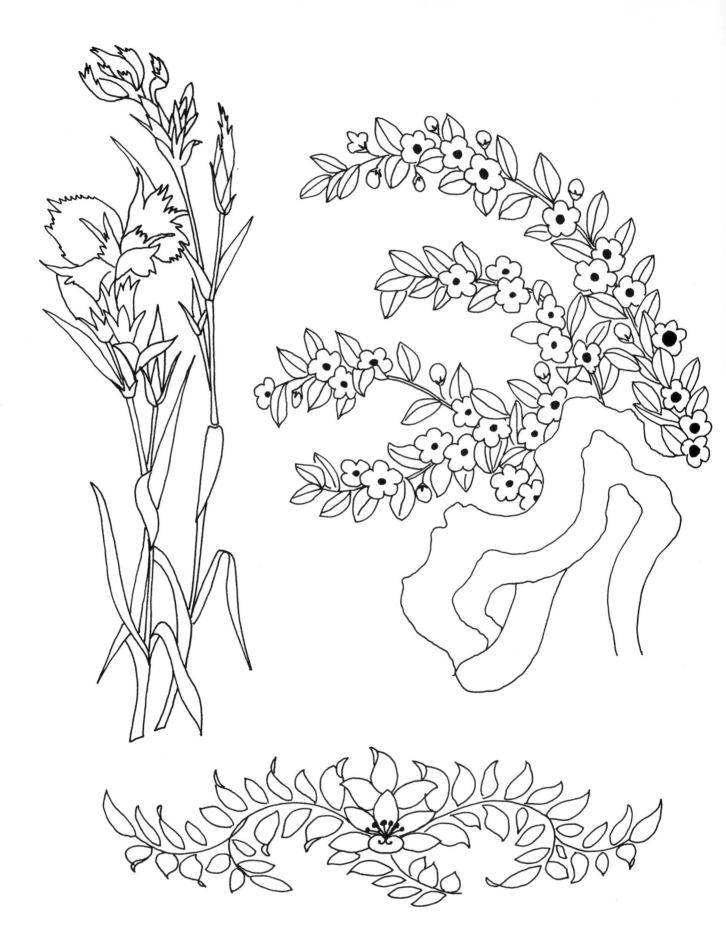

LEFT: Floral motif from a 20th-century ceramic. RIGHT: Cherry bough from a Nabeshima ceramic of the Edo period (17th–18th centuries). BOTTOM: Floral motif from a 20th-century textile.

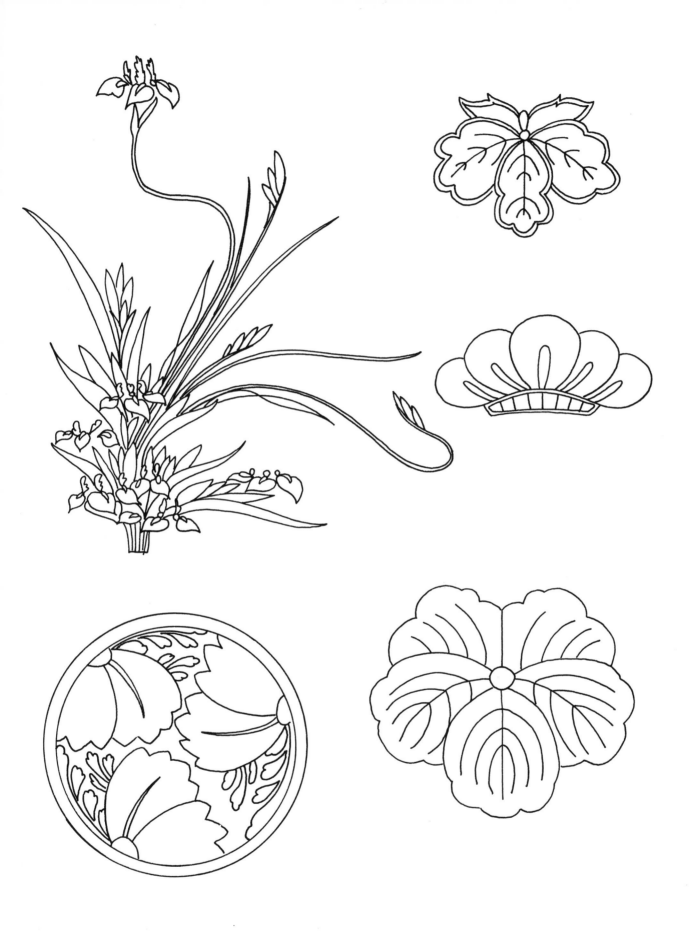

19th-century floral motifs. BOTTOM LEFT: From a resist-dyed cotton. RIGHT: From various textiles.

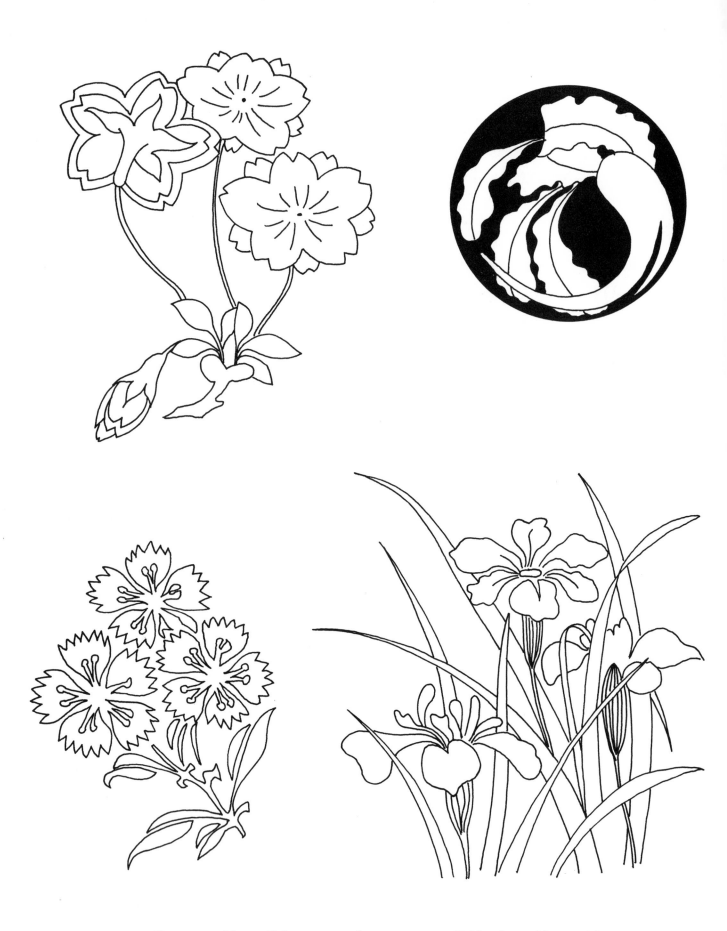

TOP LEFT: Clematis motif from a 19th-century textile. BOTTOM LEFT: Wild pink motif from a 19th-century textile. TOP RIGHT: Radish motif from an early (17th century?) Nabeshima ceramic. BOTTOM RIGHT: Iris motif from 18th-century lacquerware.

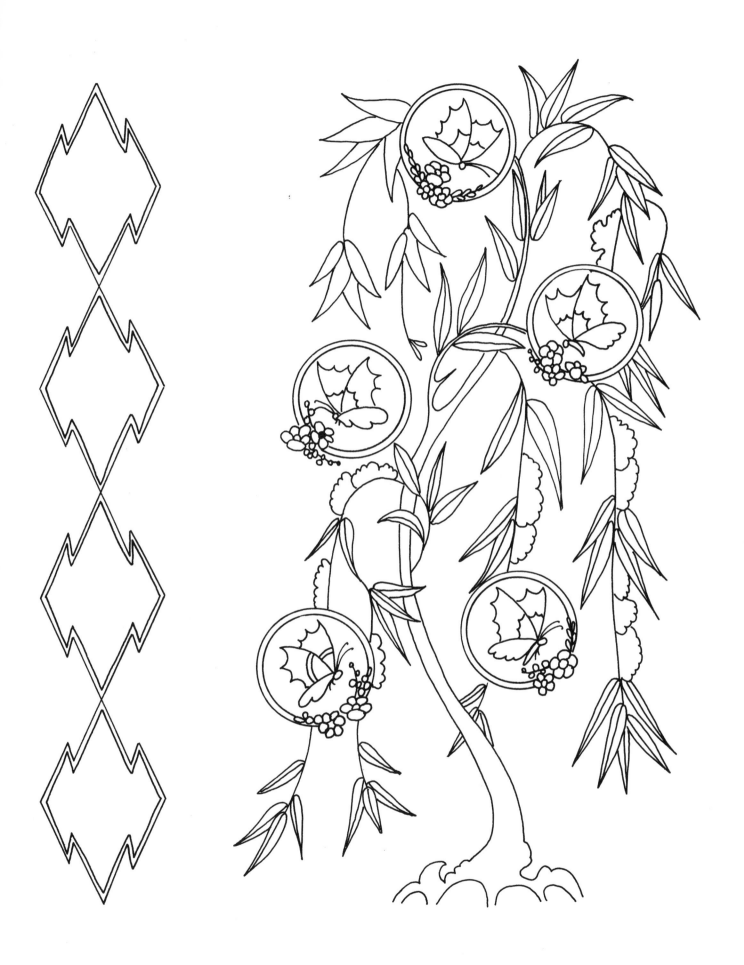

Motifs from 18th-century No costumes.

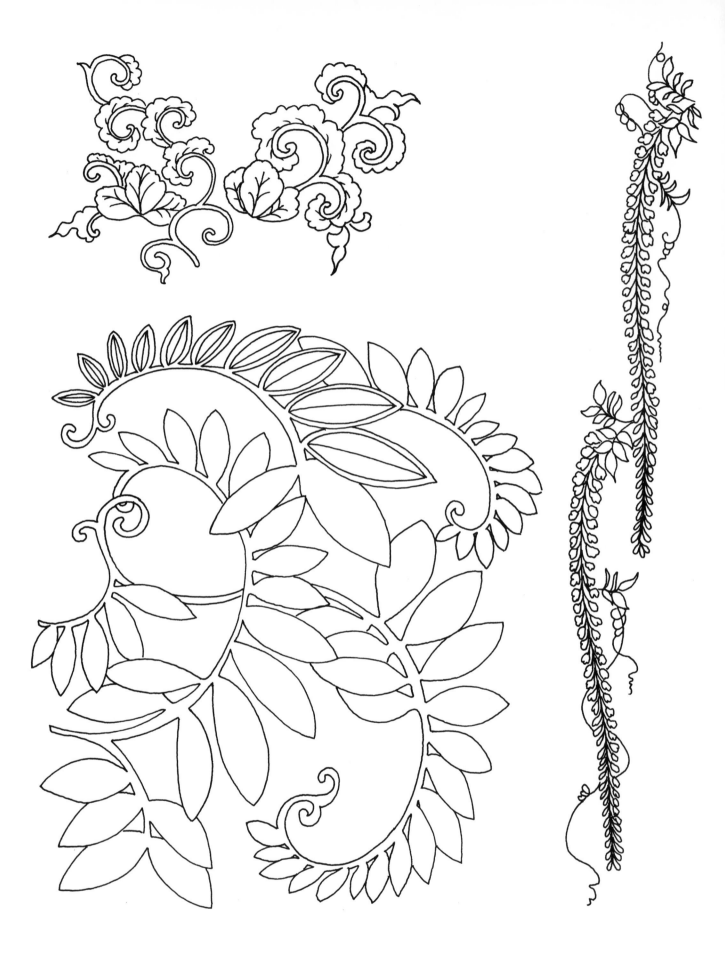

TOP LEFT: Floral motif from a 19th-century ceramic. BOTTOM LEFT: Leaf design from a 19th-century textile.
RIGHT: Wisteria motif from a 19th-century textile.

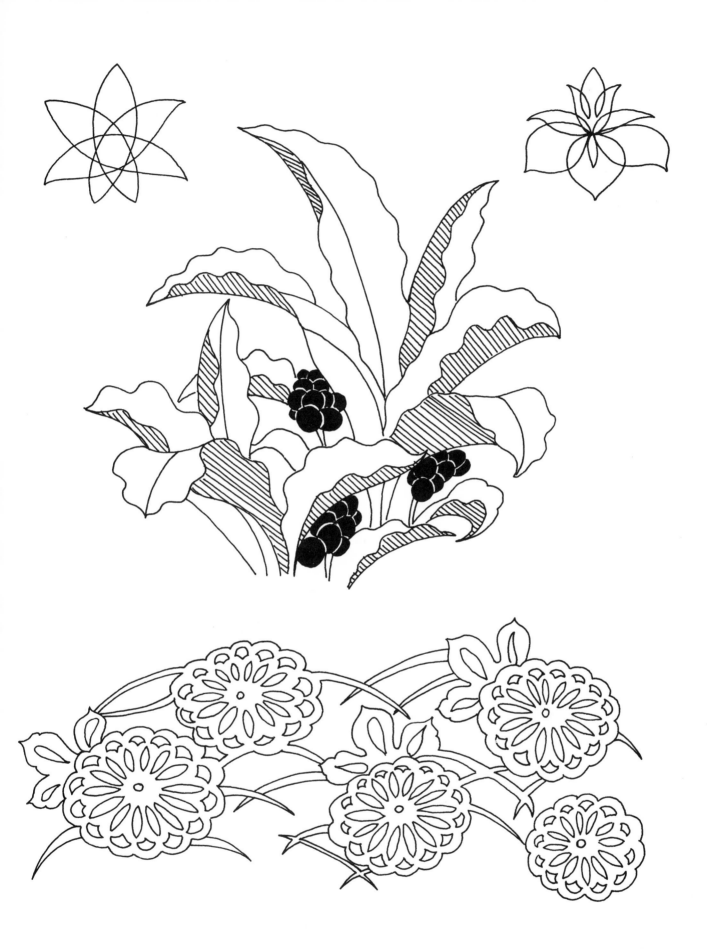

TOP LEFT & RIGHT: Floral-based designs by Katsushika Hokusai (1760–1849). CENTER: Lily-of-China motif from an 18th-century embroidery. BOTTOM: A 19th-century fabric stencil design.

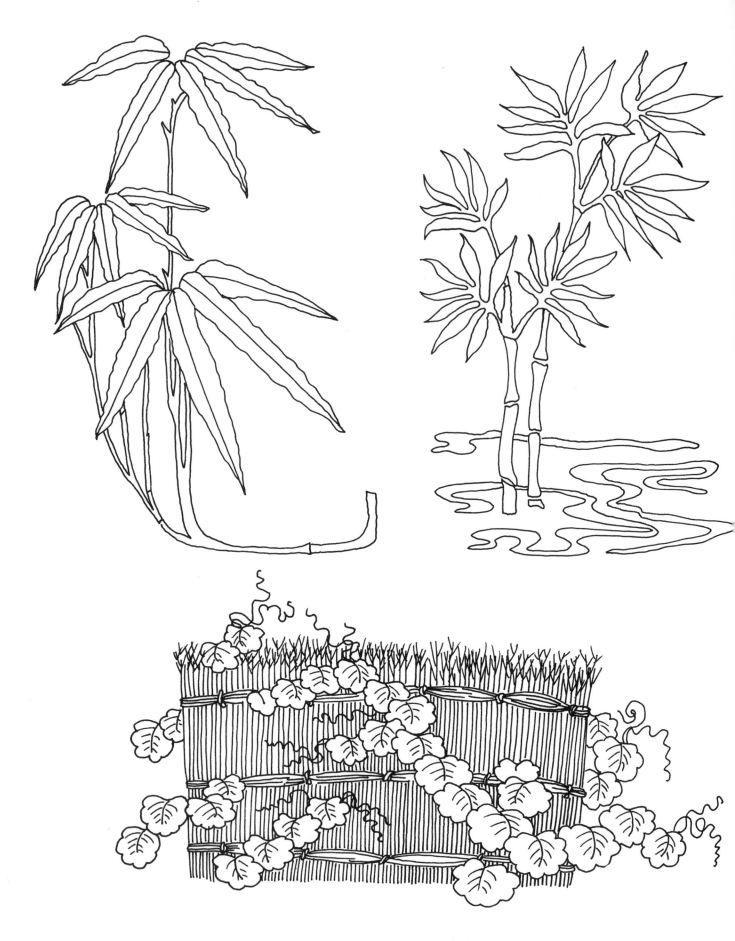

TOP: Bamboo motifs from 19th-century textiles. BOTTOM: Brushwood fence and autumnal vine design from a Nabeshima ceramic of the Edo period (17th–18th centuries).

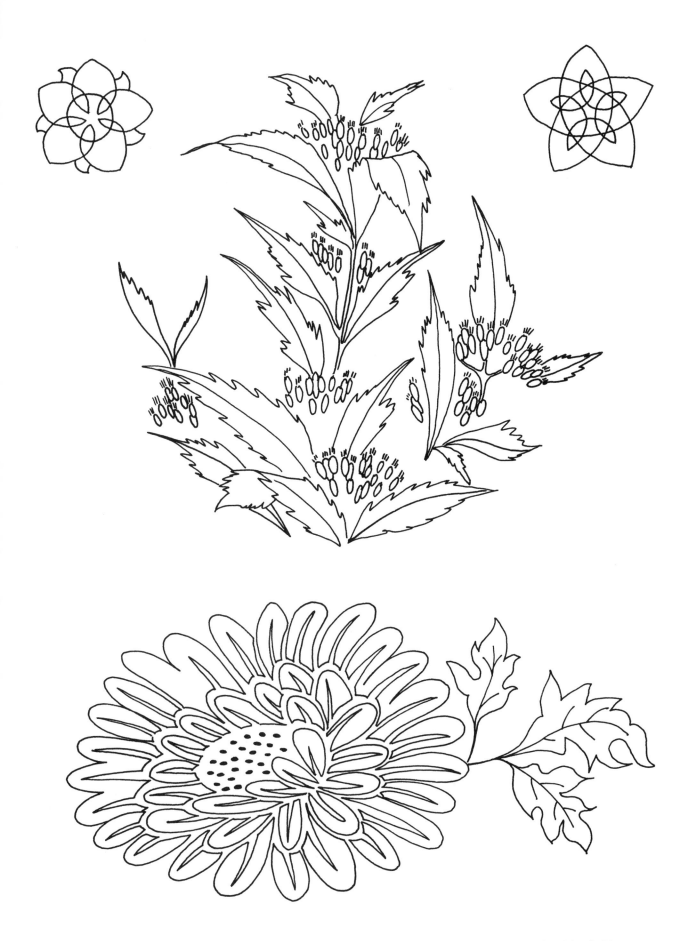

TOP LEFT & RIGHT: Floral motifs from 19th-century ink drawings. CENTER: Autumnal floral (probably thoroughwort) motif from an 18th-century Nabeshima ceramic. BOTTOM: Chrysanthemum motif from a 20th-century textile.

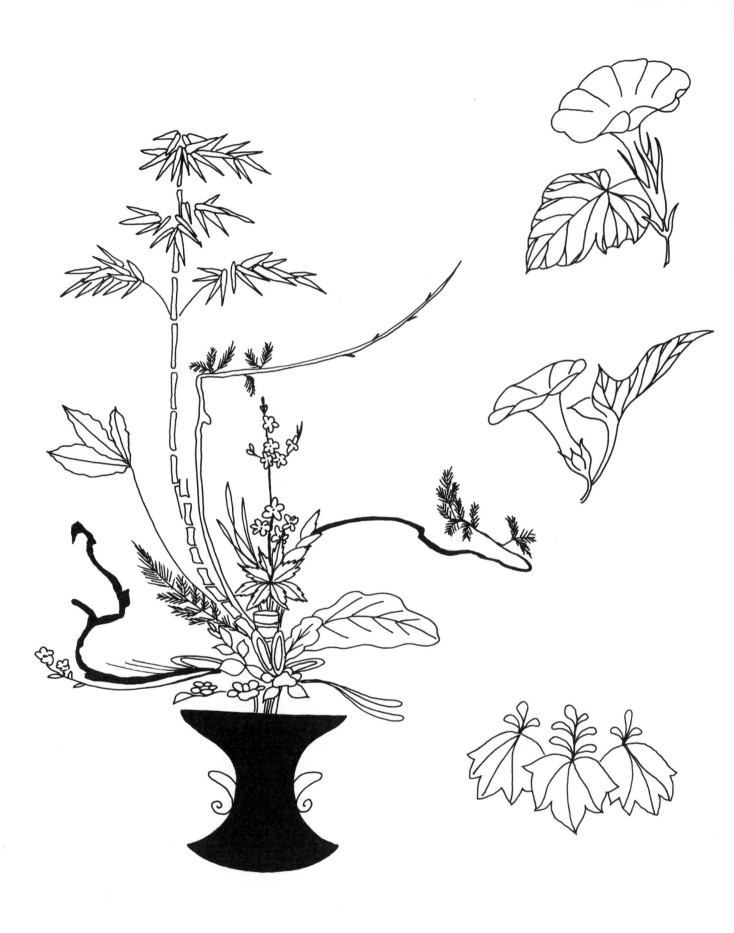

LEFT: 19th-century design of a floral arrangement including bamboo, pine, plum blossoms and other plants.
TOP RIGHT: Morning glory motifs from an 18th-century embroidery. BOTTOM RIGHT: Floral motif
from an 18th-century embroidery.

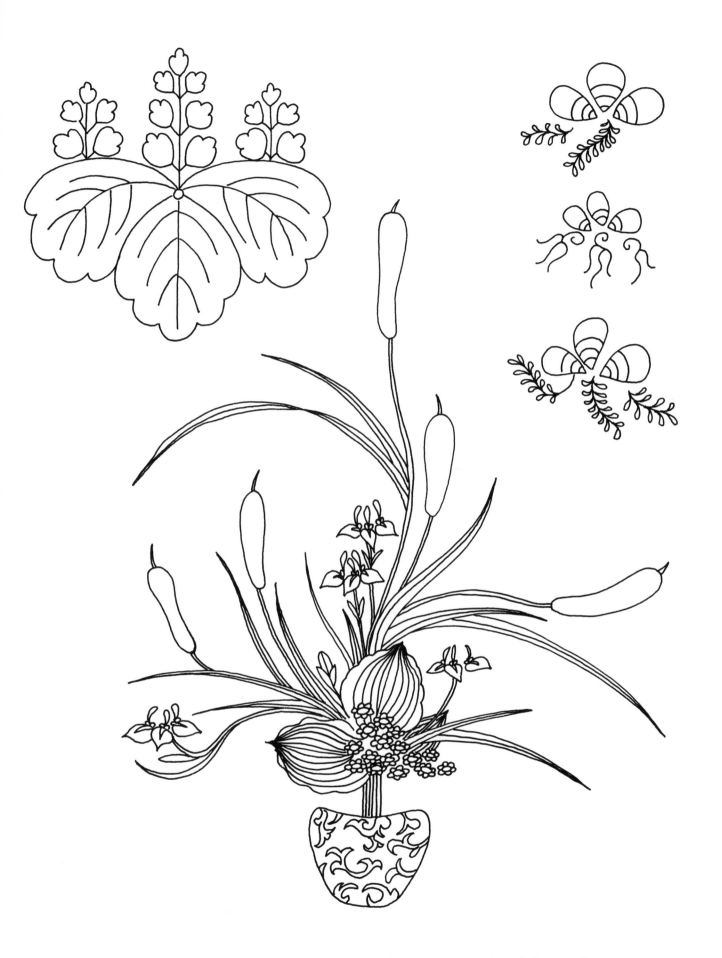

TOP LEFT: Paulownia leaf design from an 18th-century textile. TOP RIGHT: Leaf motifs from a 19th-century textile. BOTTOM: 19th-century design of a floral arrangement including cattails and pickerelweed.

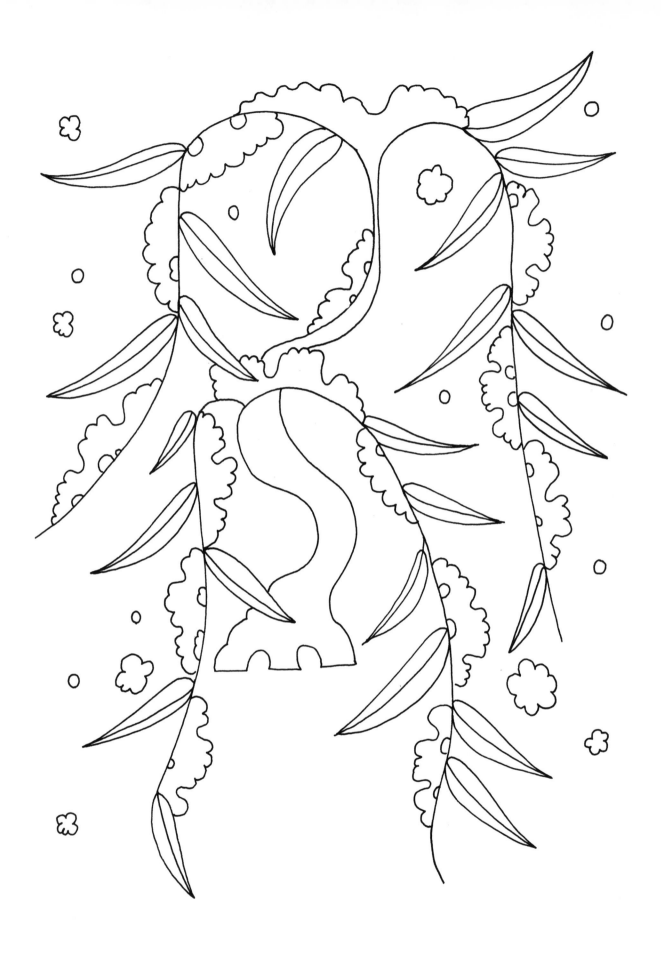

Detail from an 18th-century Nō costume.

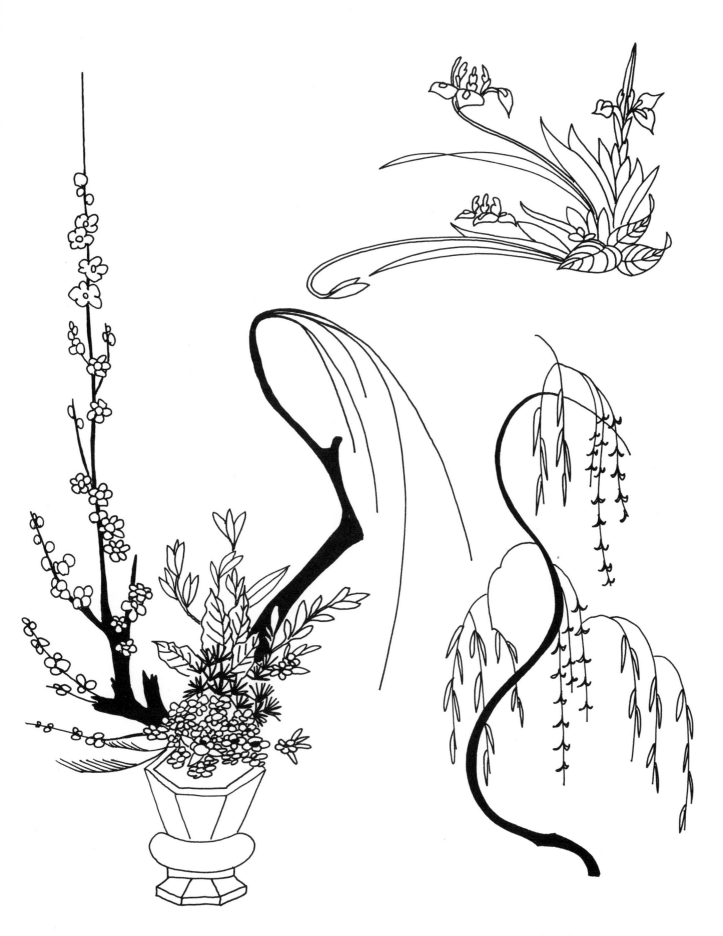

LEFT: 19th-century design of a floral arrangement including plum blossoms, pine and other plants. TOP RIGHT: 19th-century floral motif. BOTTOM RIGHT: Willow branch motif from a No robe of the Edo period (17th–18th centuries).

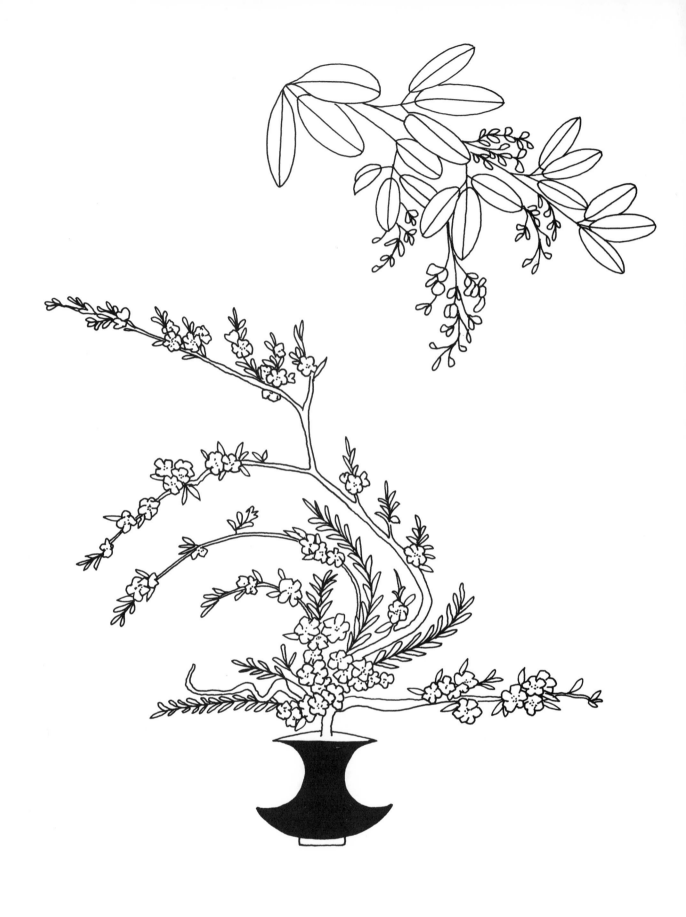

TOP: Floral motif from a 19th-century embroidery. BOTTOM: 19th-century floral (probably oleander) design.

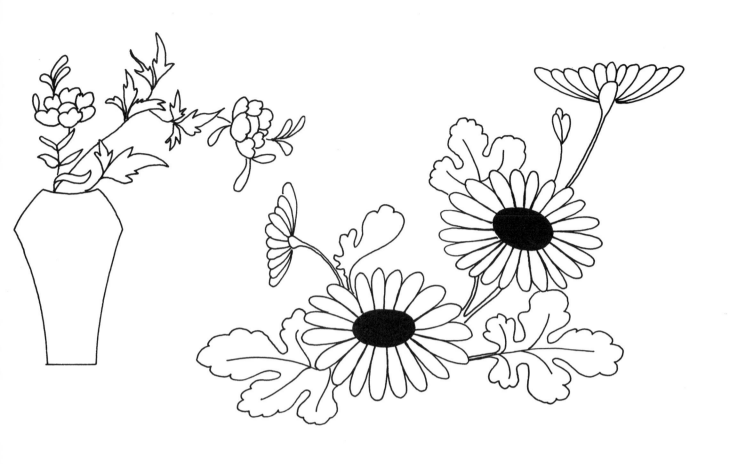

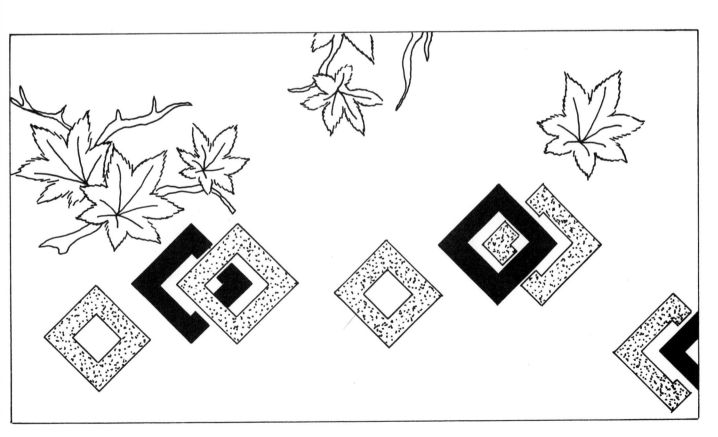

TOP LEFT: 19th-century peony motif. TOP RIGHT: Floral motif from a 19th-century embroidery. BOTTOM: 19th-century design combining geometric forms and maple leaves.

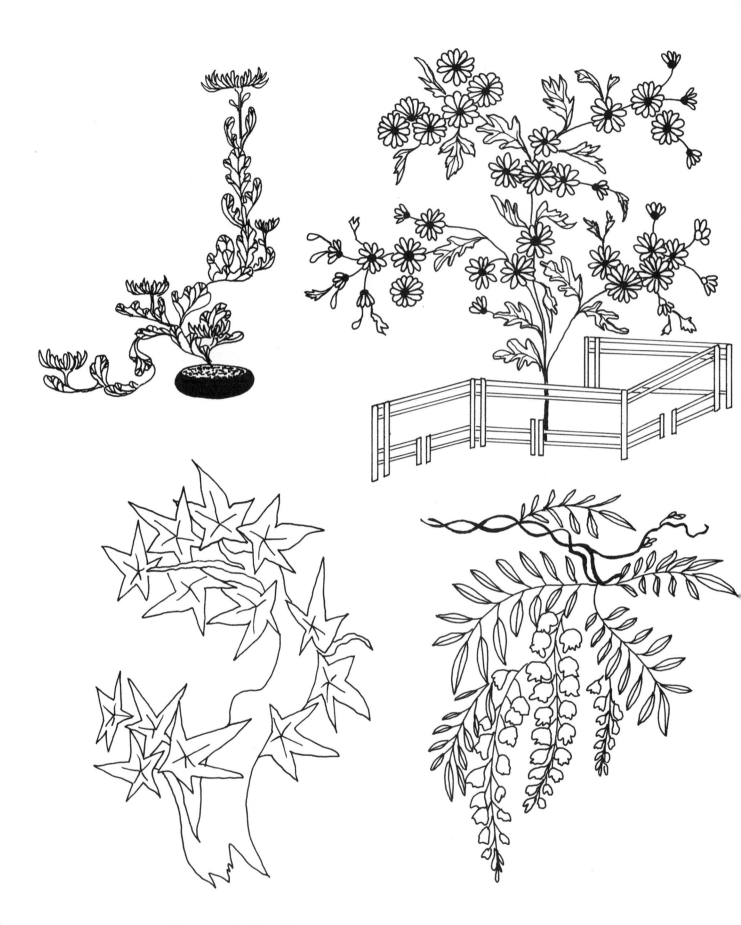

TOP LEFT: 19th-century floral motif. TOP RIGHT: Chrysanthemum and fence motif from a 19th-century textile. BOTTOM LEFT: Maple motif from a 19th-century ceramic. BOTTOM RIGHT: Wisteria motif from a late 17th-century ceramic.

16

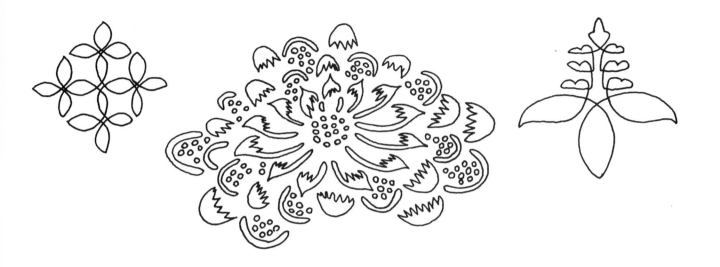

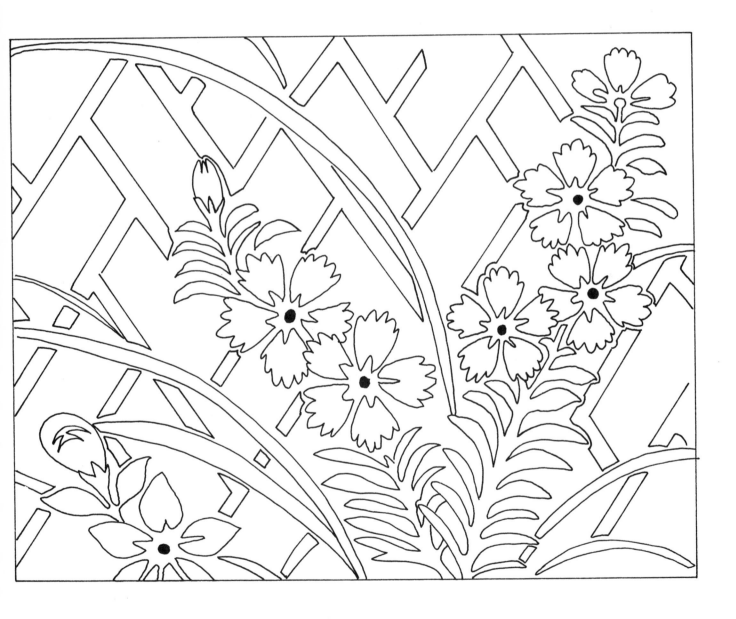

TOP LEFT & RIGHT: Floral designs by Hokusai. TOP CENTER: From a 19th-century textile. BOTTOM: Floral and geometric pattern from a 19th-century textile.

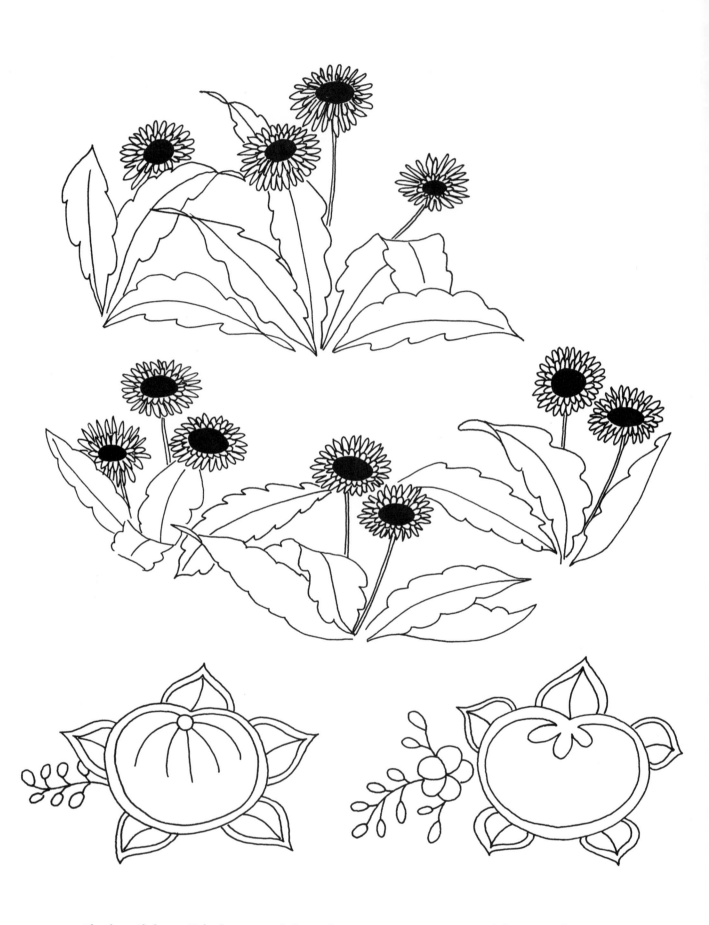

TOP: Floral motifs from a Nabeshima enameled porcelain. BOTTOM: Persimmon motifs from an 18th-century textile.

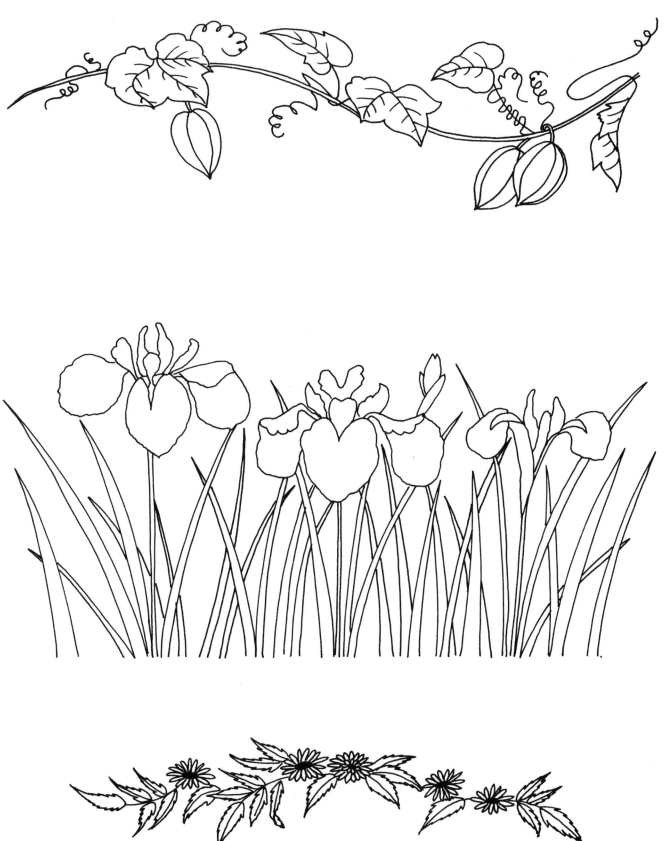

TOP: Gourd or melon motif from a 19th-century porcelain. CENTER: Iris motif from a painted fan used in the No drama. BOTTOM: Floral motif from a 20th-century textile.

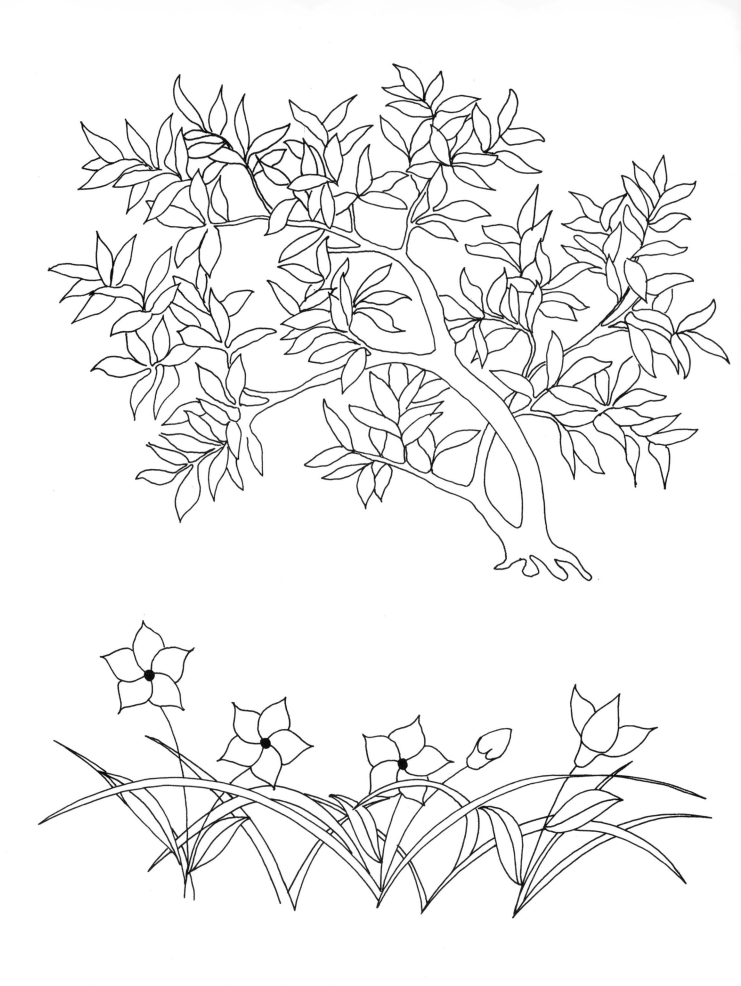

TOP: From an 18th-century lacquered screen. BOTTOM: Bellflower motif from a 19th-century fan.

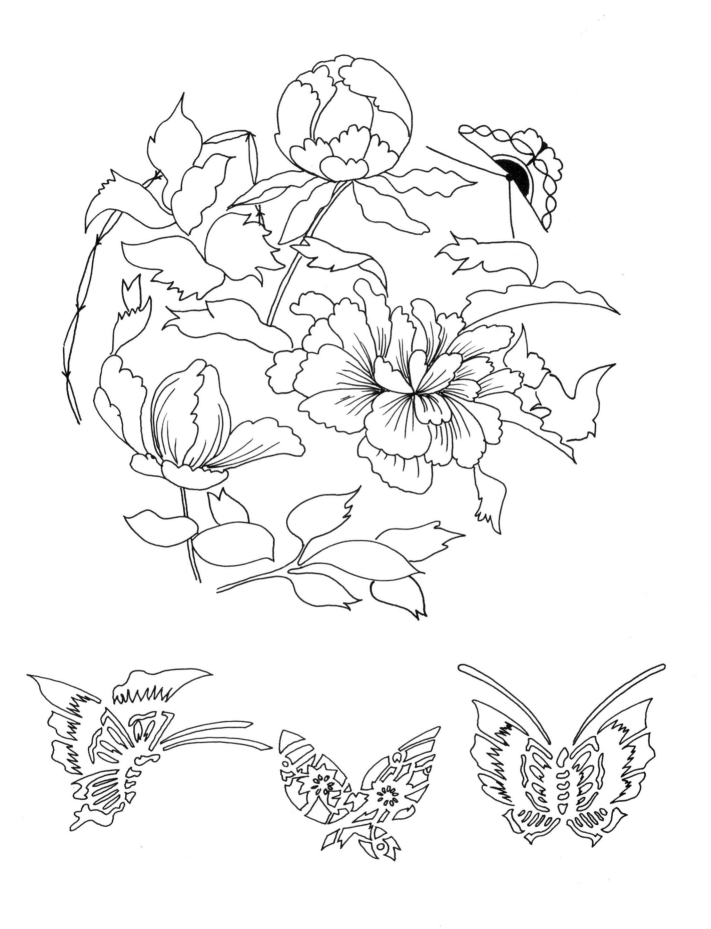

TOP: Peony and butterfly design from an 18th-century ceramic. BOTTOM: Butterfly designs from a
19th-century stenciled textile.

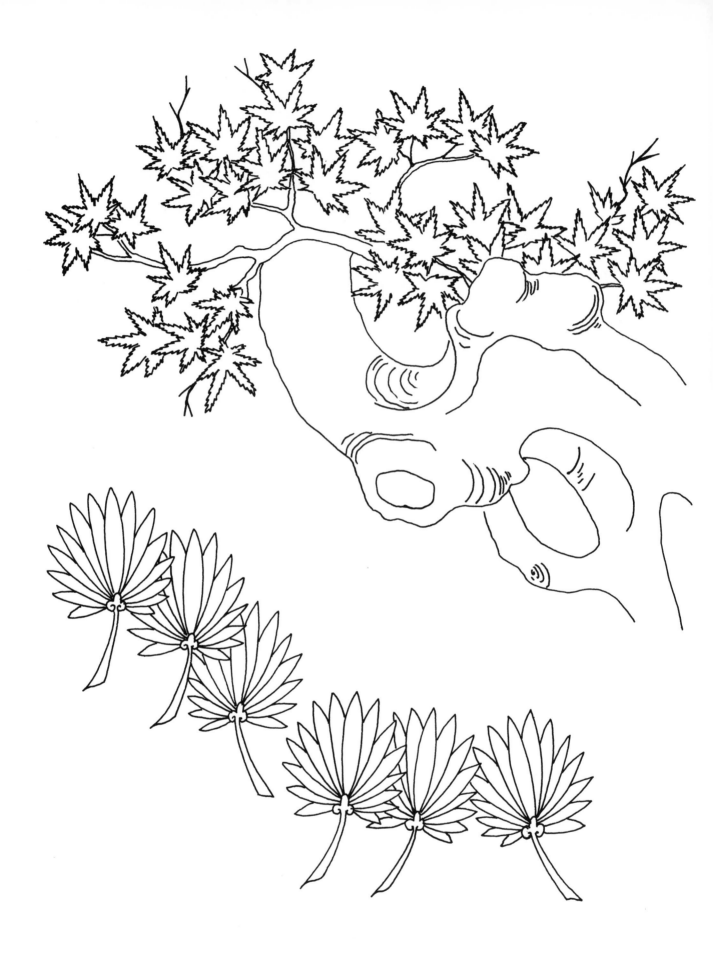

TOP: Maple motif from an 18th-century folding screen of silk. BOTTOM: Hemp palm motifs from a Nabeshima enameled porcelain.

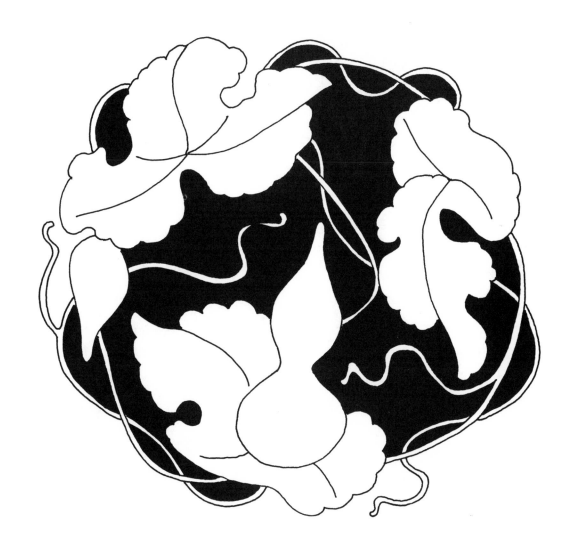

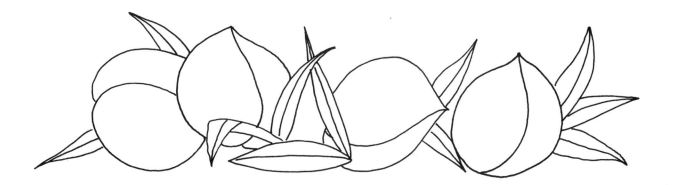

TOP: Gourd motif from a Kutani enameled ceramic. BOTTOM: Peach motif from a Nabeshima ceramic.

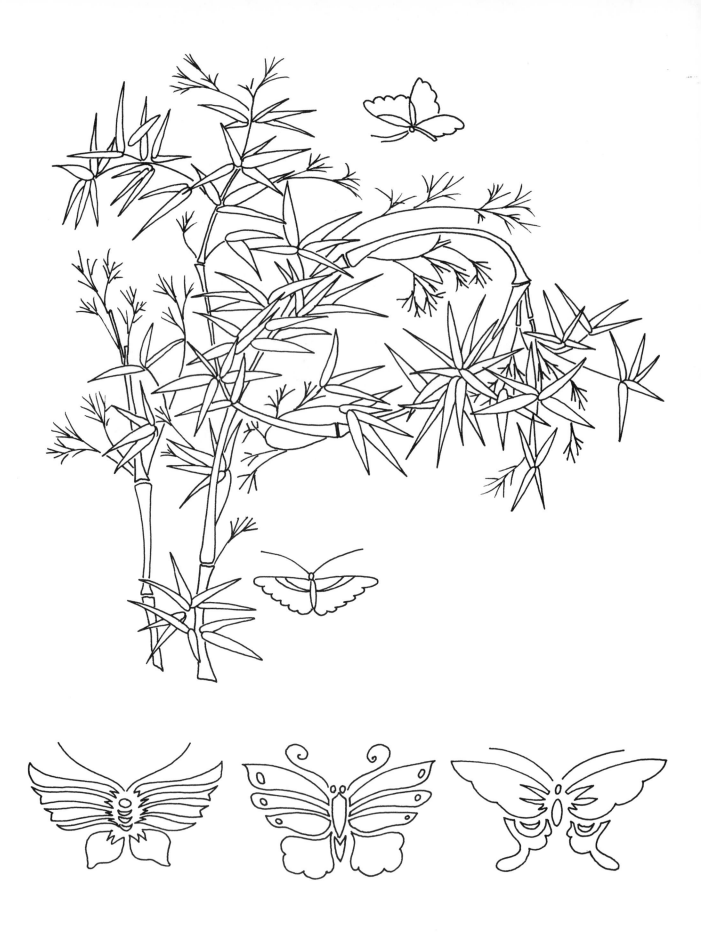

TOP: Bamboo and butterfly motif from a 20th-century ceramic. BOTTOM: 18th-century stencil designs of butterflies.

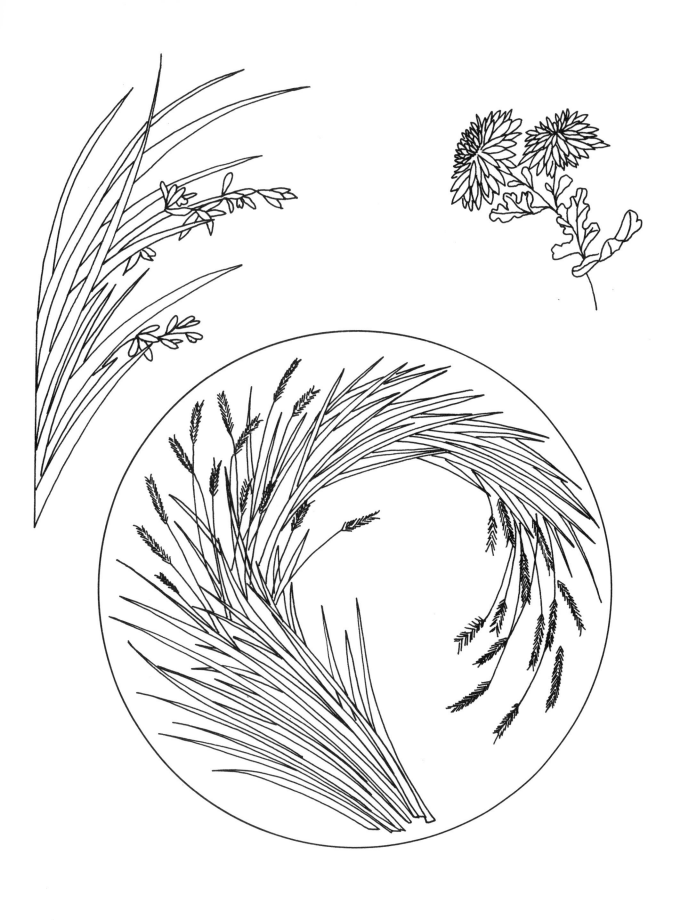

TOP LEFT: Floral motif from a 19th-century textile. TOP RIGHT: Chrysanthemum motif from a 19th-century textile. BOTTOM: Grass motif (the "felled-reeds" pattern) from a 20th-century Kakiemon ceramic.

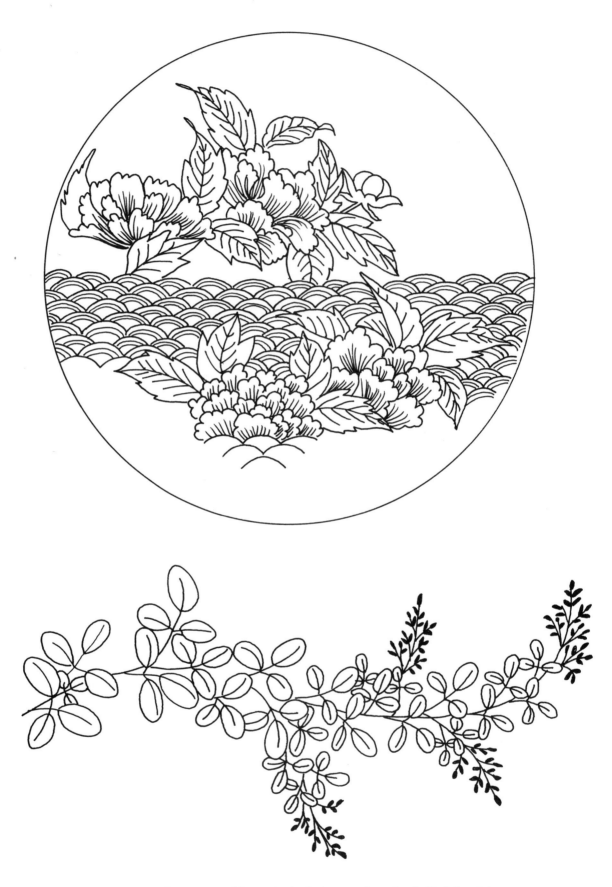

TOP: Ocean waves and peony motif from a Nabeshima porcelain, first half of the 18th century.
BOTTOM: Lespedeza (bush clover) motif from a 19th-century textile.

26

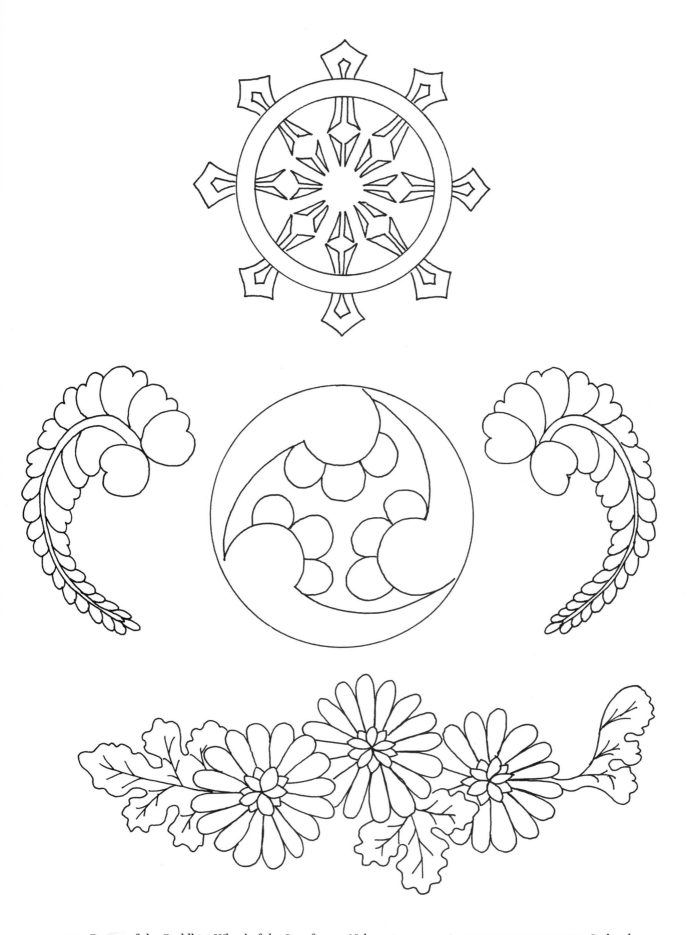

TOP: Design of the Buddhist Wheel of the Law from a 19th-century ceramic. CENTER LEFT & RIGHT: Stylized wisteria motifs from a 19th-century textile. CENTER: *Mon* (family crest), representing cloves, from a 19th-century textile. BOTTOM: Chrysanthemum motif.

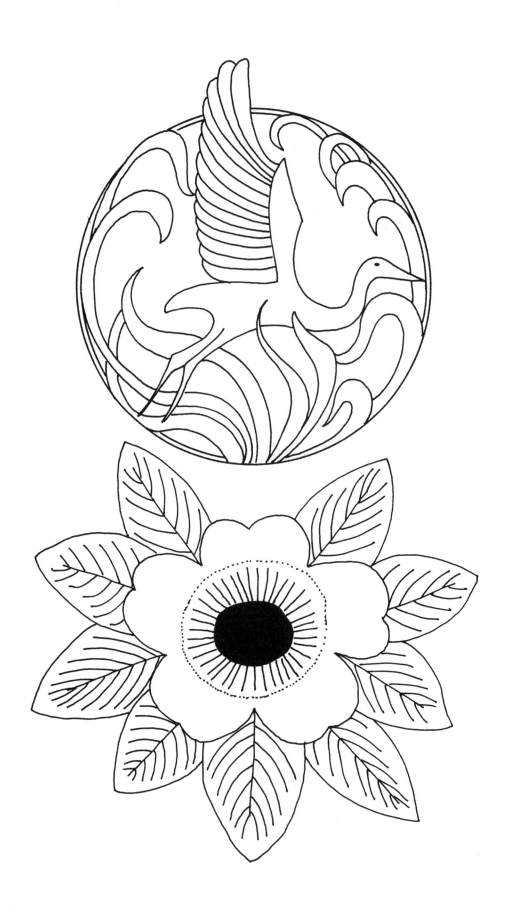

TOP: Crane motif from a 19th-century iron sword guard. BOTTOM: Cherry or plum blossom motif from a 19th-century textile ornament.

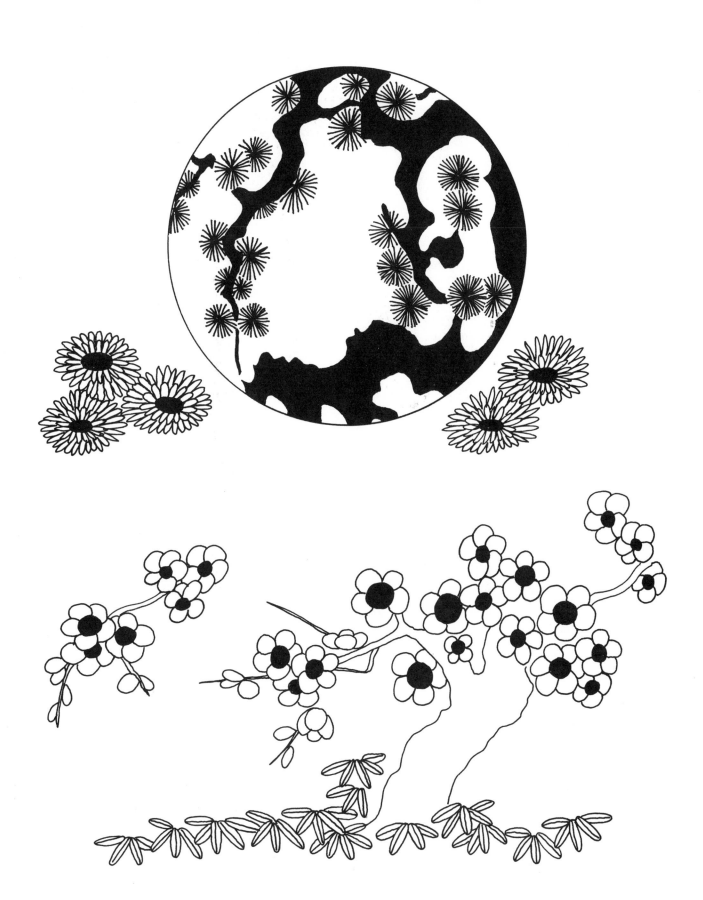

TOP CENTER: Pine motif from a Nabeshima ceramic. TOP LEFT & RIGHT: Chrysanthemum motifs from a 19th-century textile. BOTTOM: Oleander motif from a 19th-century textile.

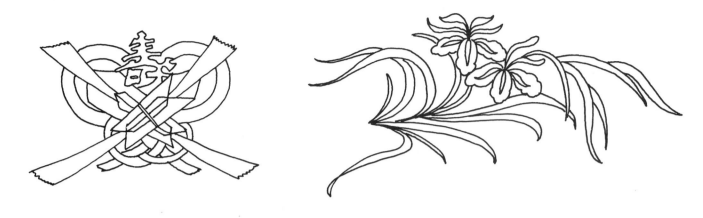

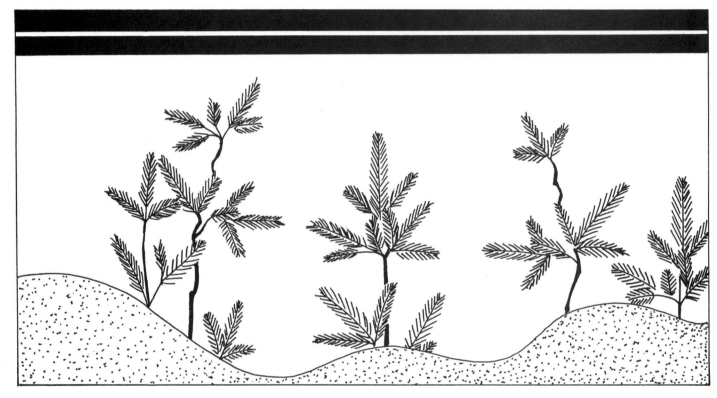

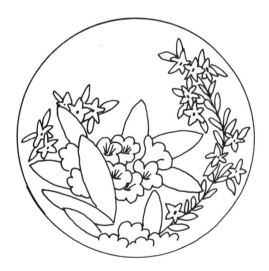

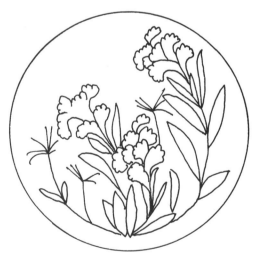

TOP LEFT: Design from a 19th-century store sign. TOP RIGHT: Iris motif from a ceramic dated 1699. CENTER: Pine and sand dune motif from a 19th-century textile. BOTTOM LEFT: Rhododendron and azalea design from a Nabeshima enameled ceramic. BOTTOM RIGHT: Cockscomb (*Celosia*) motif from a Nabeshima ceramic.

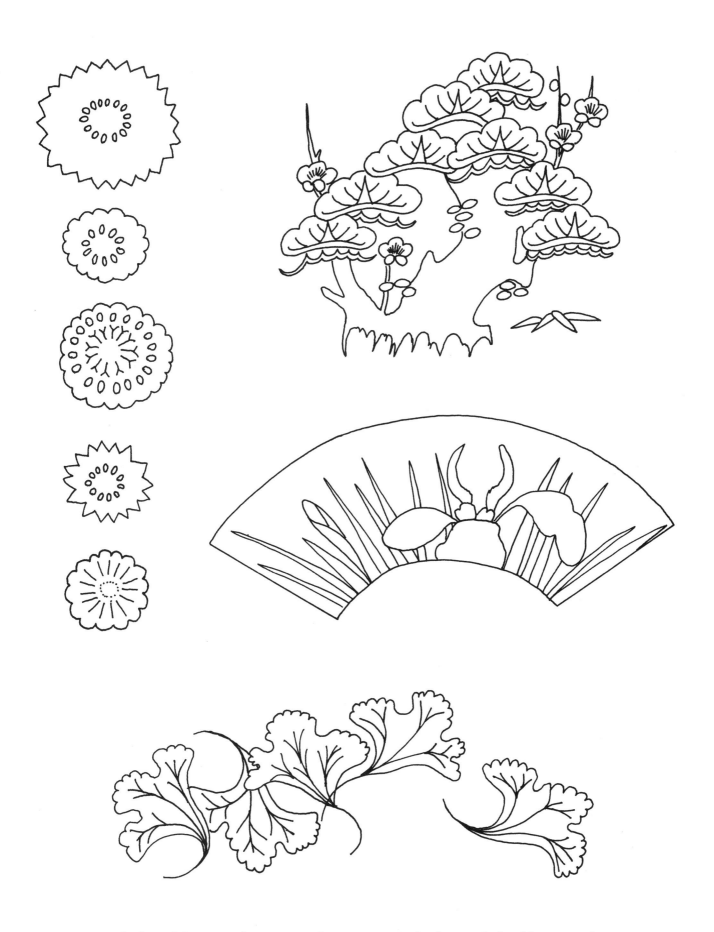

LEFT: Floral motifs from an 18th-century textile. TOP RIGHT: Stylized pine and plum blossom motif from a 19th-century textile. CENTER RIGHT: Iris motif from an 18th-century silk fan.
BOTTOM: Gingko leaf motif from a 19th-century textile.

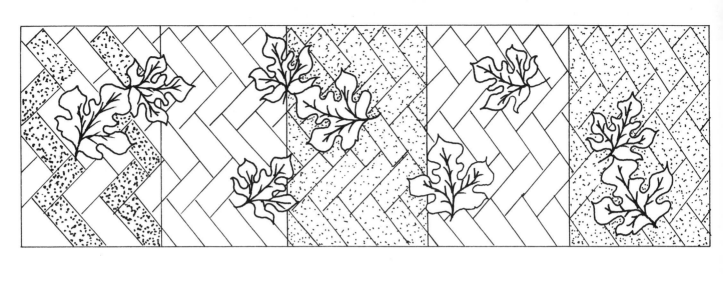

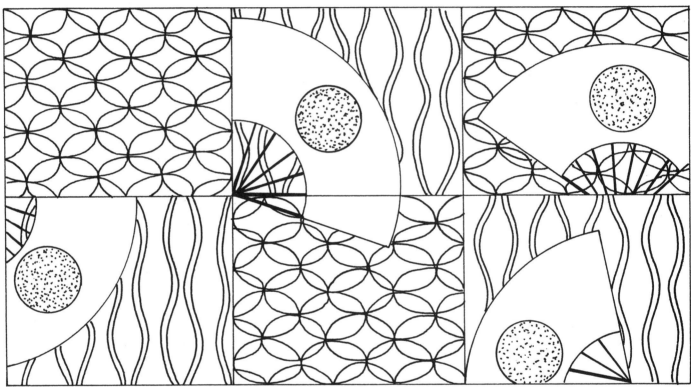

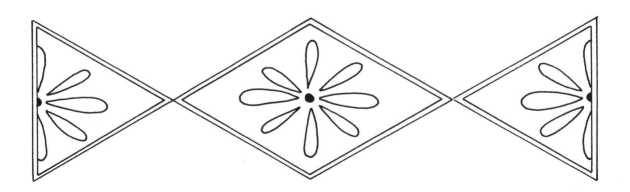

TOP: Paper mulberry leaf motif on a basket-weave pattern from a 19th-century textile. CENTER: Geometric pattern overlaid with fan motifs, from a 19th-century textile. BOTTOM: From a 19th-century wood carving.

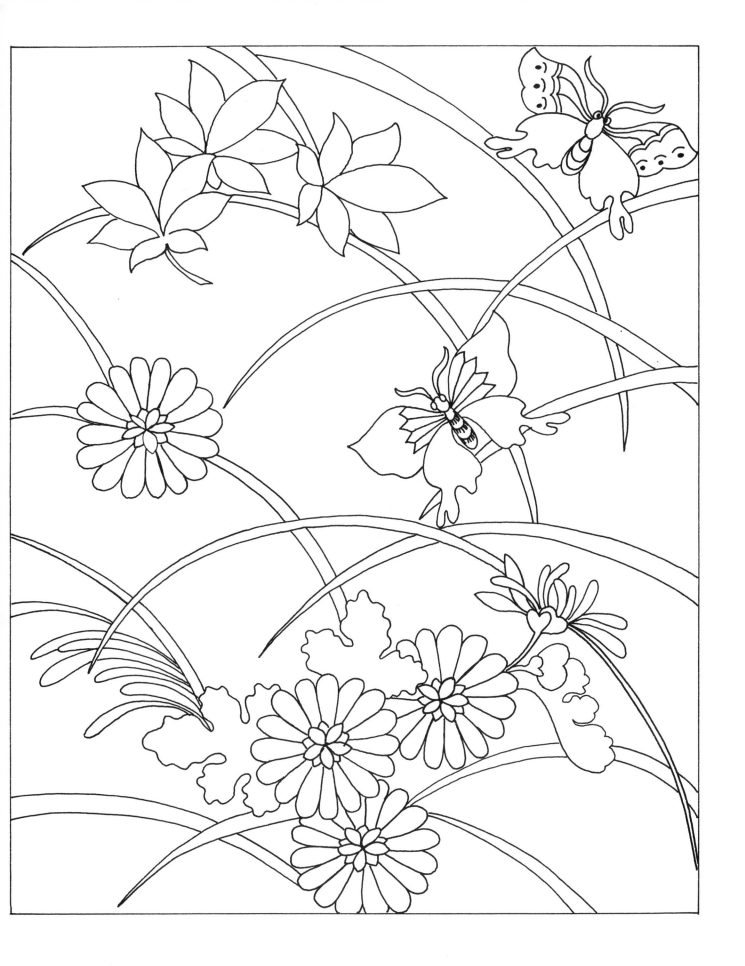

Detail of a 17th-century Nō robe adorned with maple leaf, chrysanthemum and butterfly motifs.

33

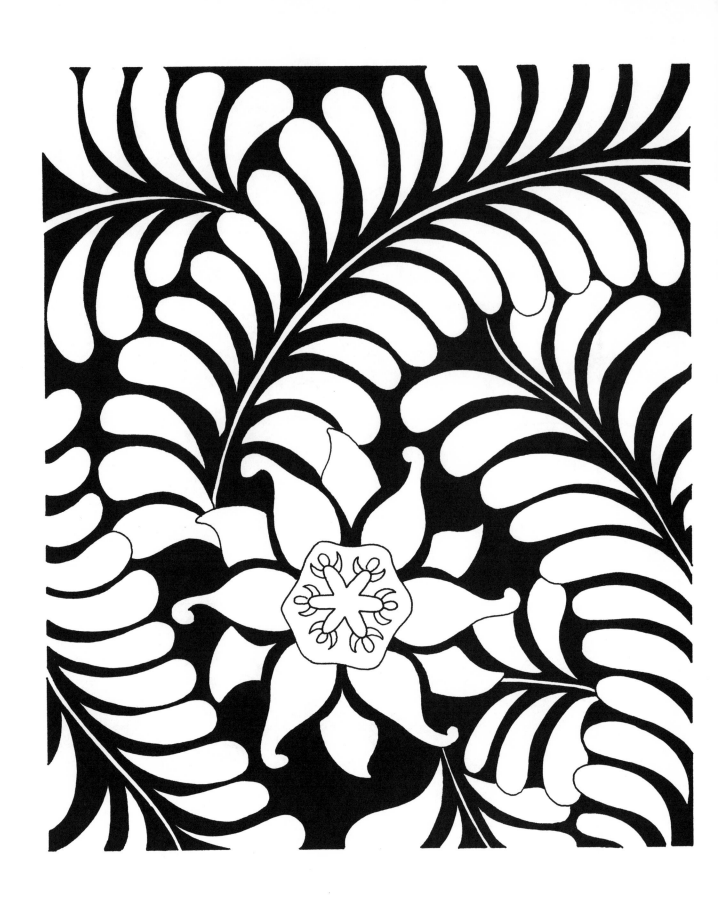

Floral (palm fronds and blossoms?) motif from a 19th-century textile.

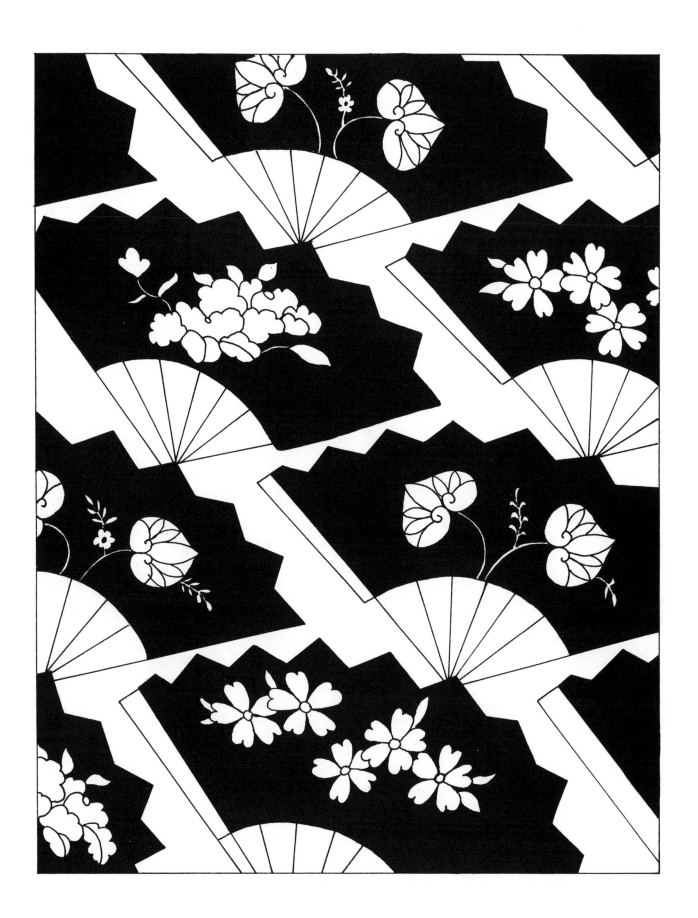

Repeating pattern of fans adorned with floral motifs (mallow and cherry) from a 20th-century textile.

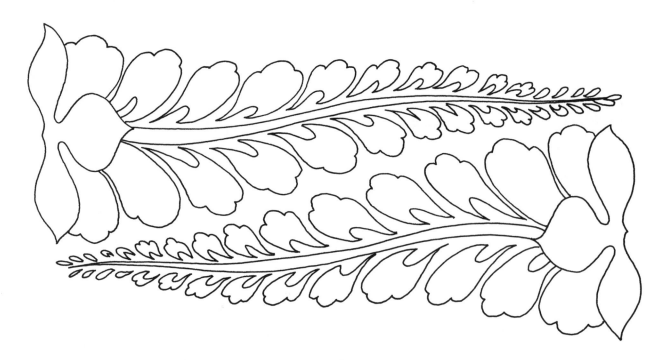

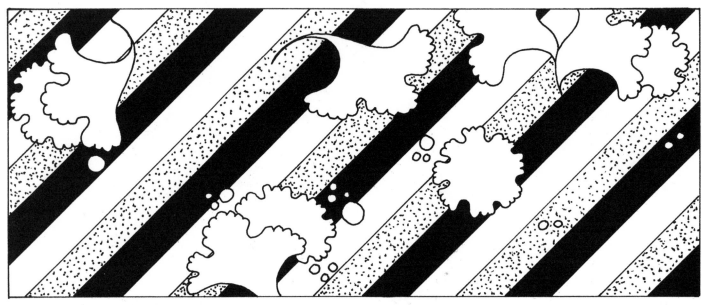

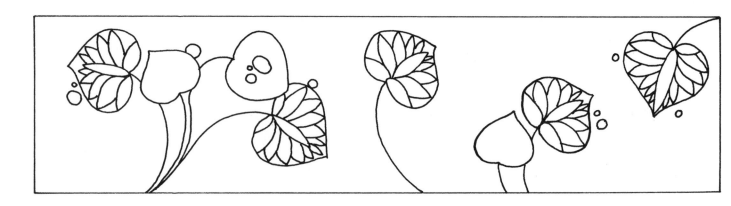

TOP: Conventionalized wisteria blossoms from a 19th-century textile. CENTER: Gingko leaf
motifs on a background of diagonal bands, from a 19th-century textile.
BOTTOM: Mallow leaf motifs from an 18th-century textile.

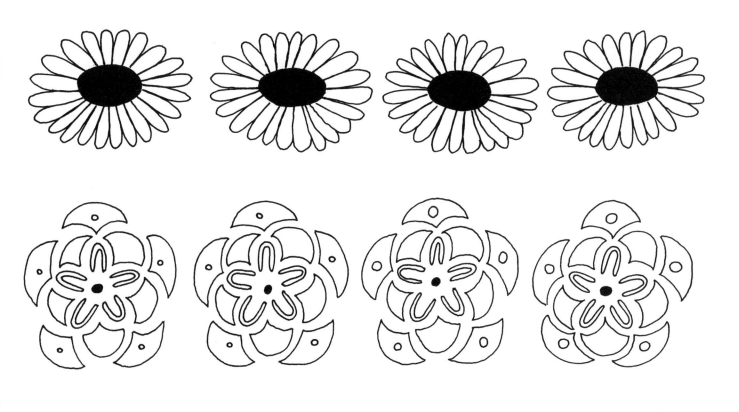

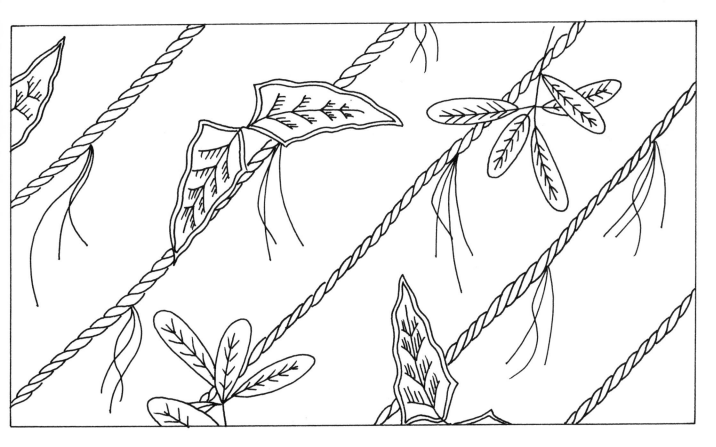

TOP: Floral motifs from a 19th-century textile. CENTER: Floral motifs from a 19th-century textile. BOTTOM: Leaf and rope motif from a No costume of the Edo period (17th–18th centuries).

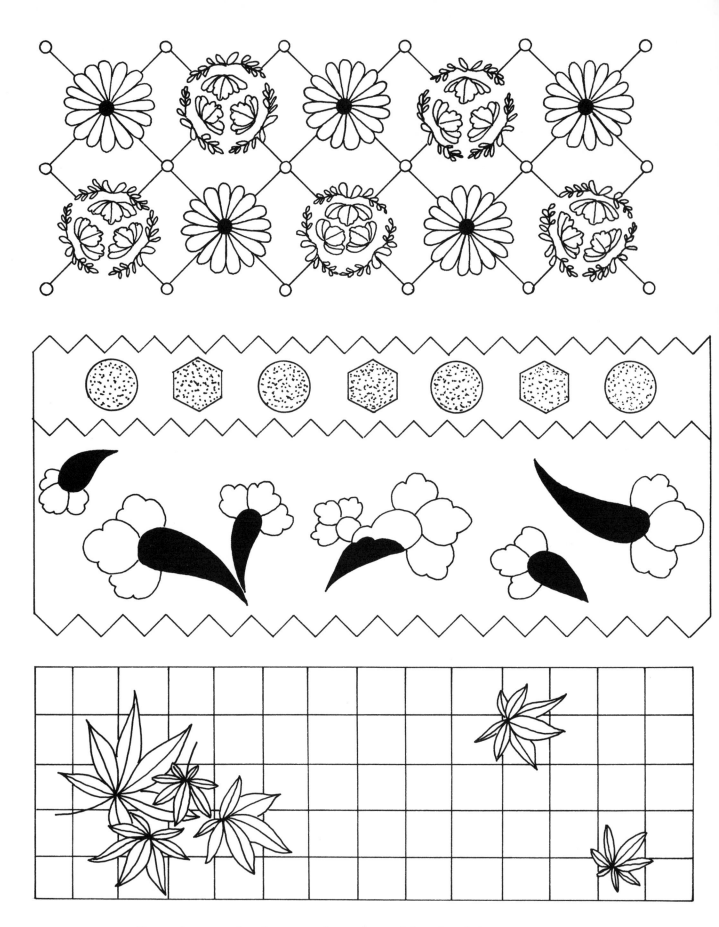

TOP: Chrysanthemum and paulownia motifs on a diamond-shaped grid, from an 18th-century textile.
CENTER: Radish motifs from a 20th-century textile. BOTTOM: Maple leaf motifs
on a square grid from a 19th-century textile.

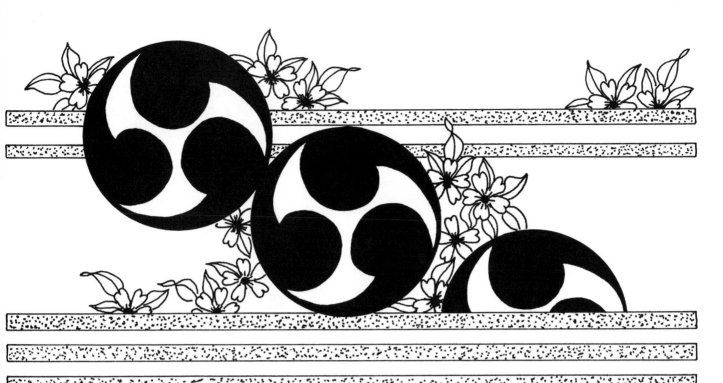

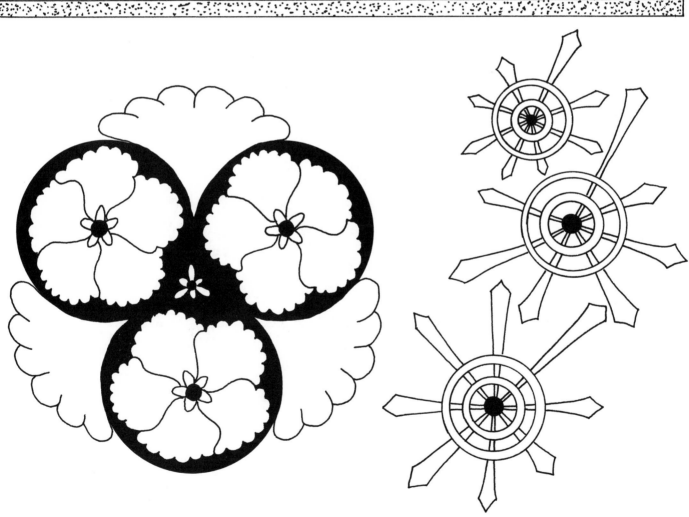

TOP: Cherry blossoms and *tomoe* ("large commas") motifs from an 18th-century Nabeshima ceramic.
BOTTOM LEFT: "Cotton rose" design from a Nabeshima ceramic.
BOTTOM RIGHT: Designs from an 18th-century No robe.

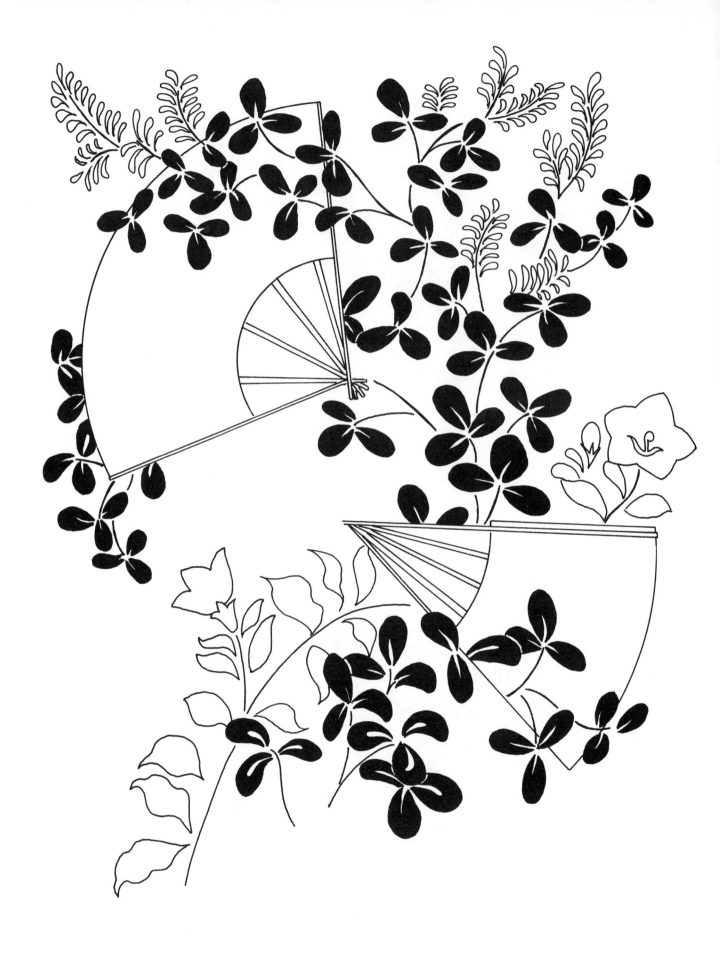

Lespedeza (bush clover), balloonflower and fan motif from a 19th-century textile.

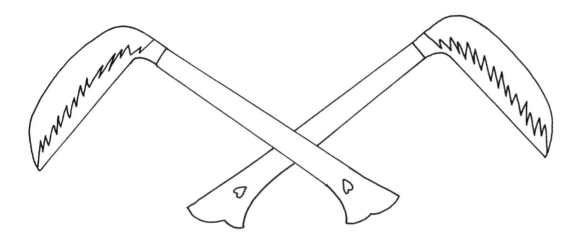

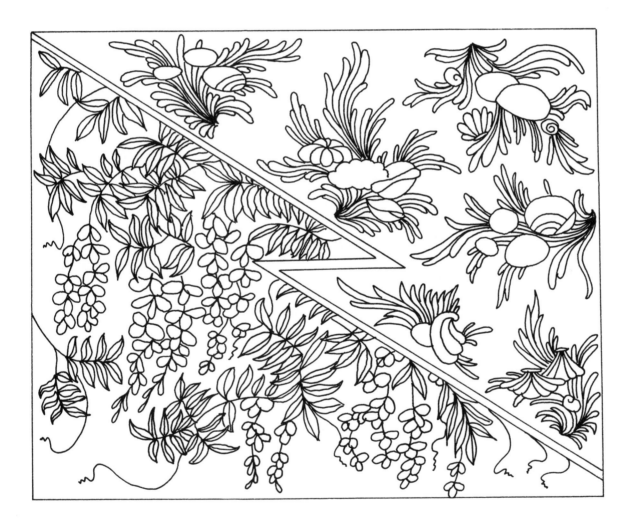

TOP: Crossed sickle motif from a 17th-century textile. BOTTOM: Floral motifs from 19th-century lacquerware.

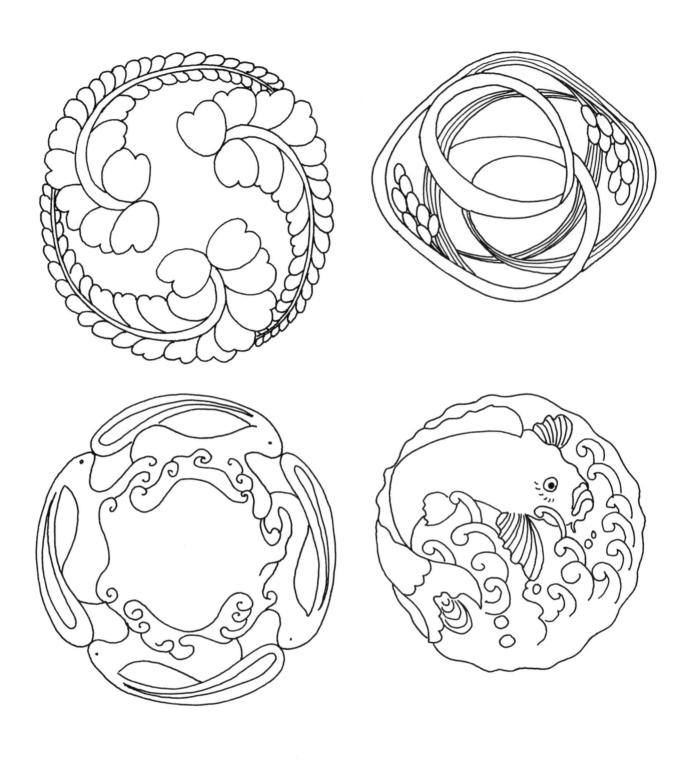

COUNTERCLOCKWISE FROM TOP RIGHT: Motifs from 18th-century bronze sword guards: rice plant (?) motif; wisteria motif; rabbit motif. BOTTOM RIGHT: Fish design from a 19th-century textile.

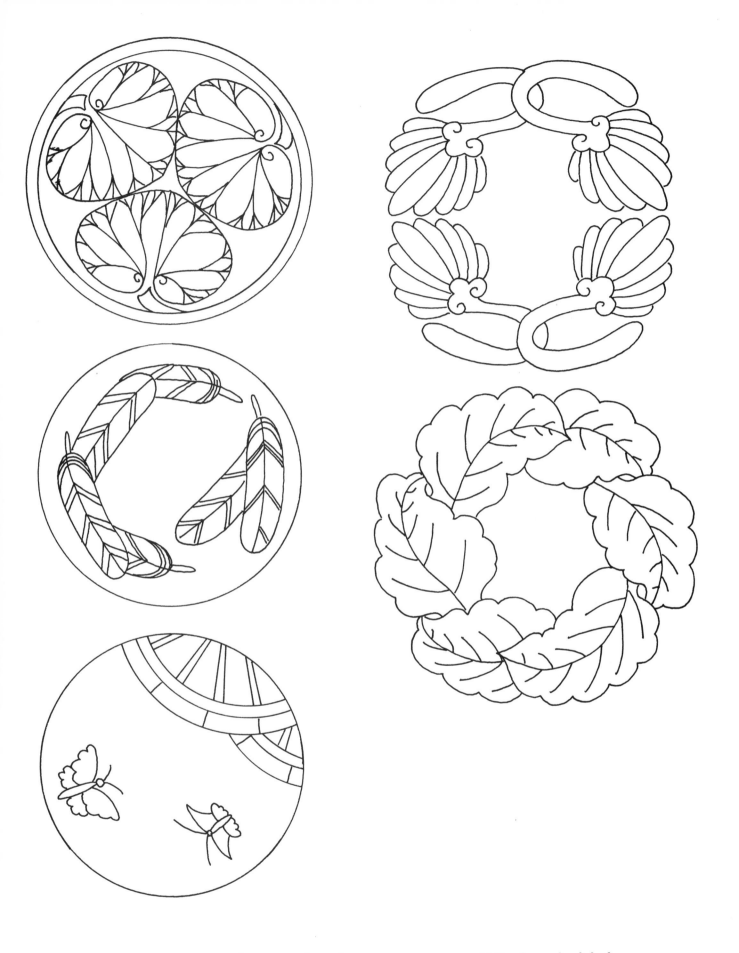

Designs from 18th-century bronze sword guards. LEFT, TOP TO BOTTOM: Mallow leaves; hawk feathers; butterflies and wheels. RIGHT, TOP TO BOTTOM: Hemp palms; oak leaves.

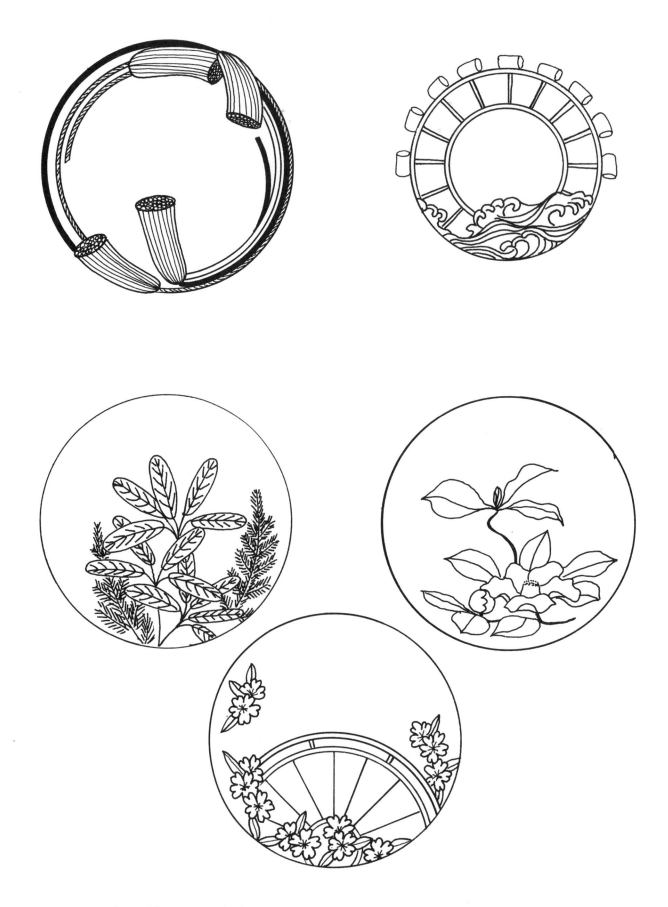

Designs from 18th-century Nabeshima ceramics. TOP LEFT: Lotus capsules. TOP RIGHT: Waterwheel and waves. CENTER LEFT: *Daphniphyllum* (a small evergreen tree) and fern. CENTER RIGHT: Dogwood sprig. BOTTOM: Wheel and plum blossoms.

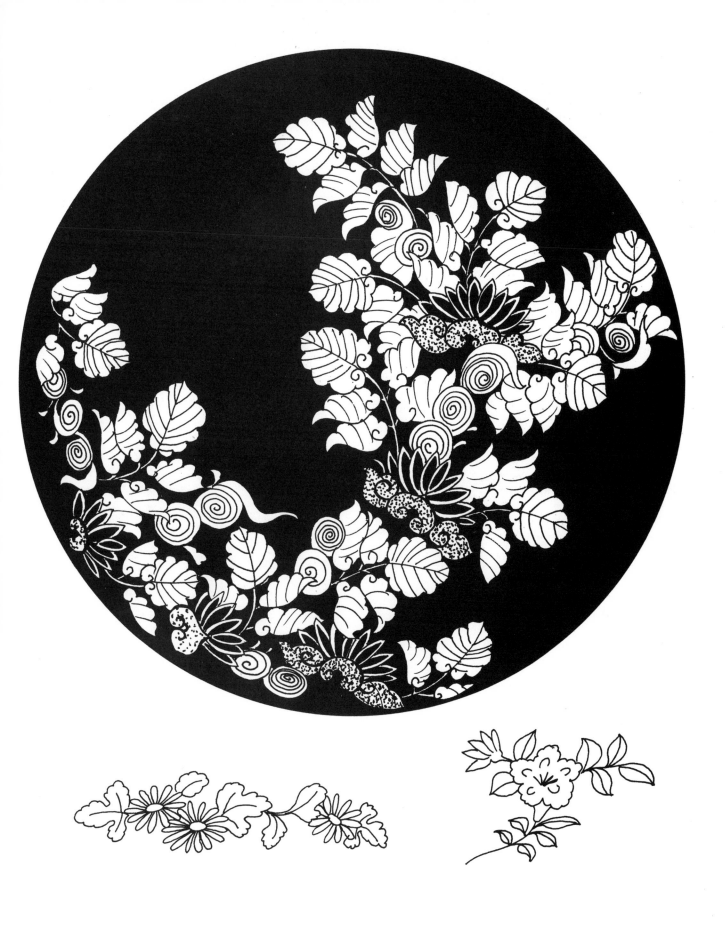

TOP: Oak bough and snail (?) motif from an 18th-century Nabeshima ceramic.
BOTTOM: Floral motifs from a 19th-century textile.

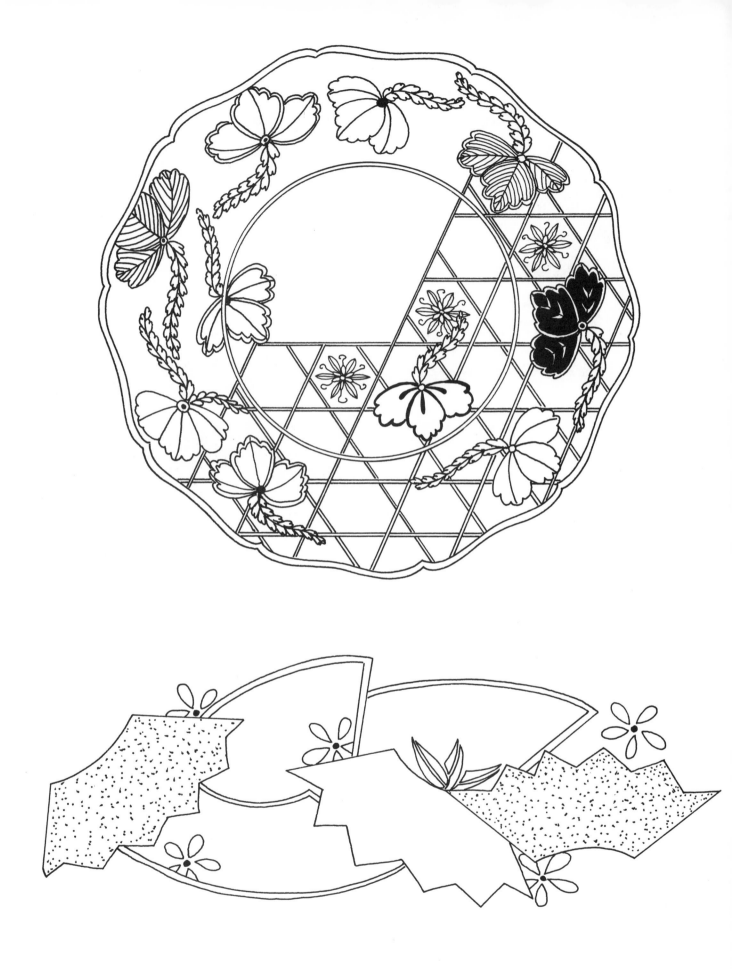

TOP: From a Shibuemon-style ceramic. BOTTOM: From a 20th-century textile.

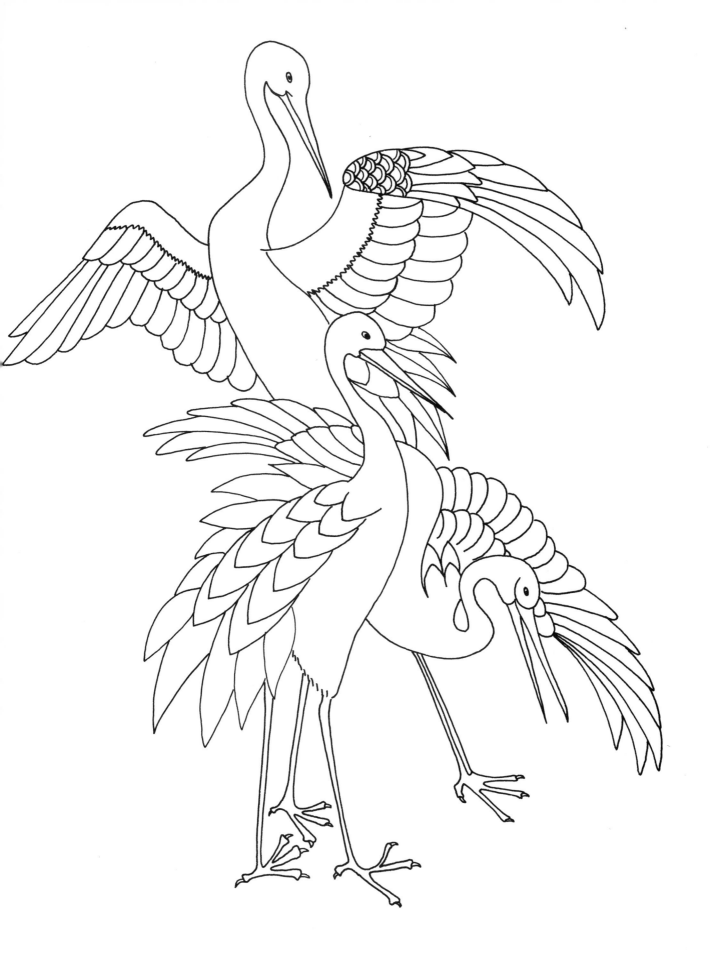

Crane motif from a 19th-century textile.

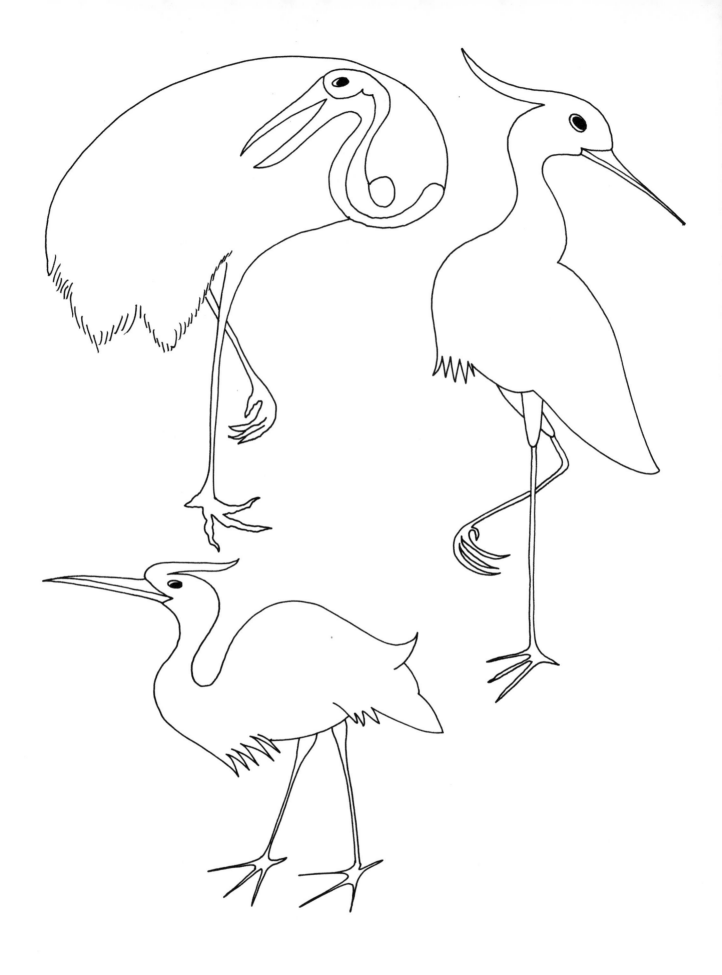

TOP LEFT: Crane motif from an early Nabeshima ceramic. RIGHT & BOTTOM: Heron motifs from a 19th-century textile.

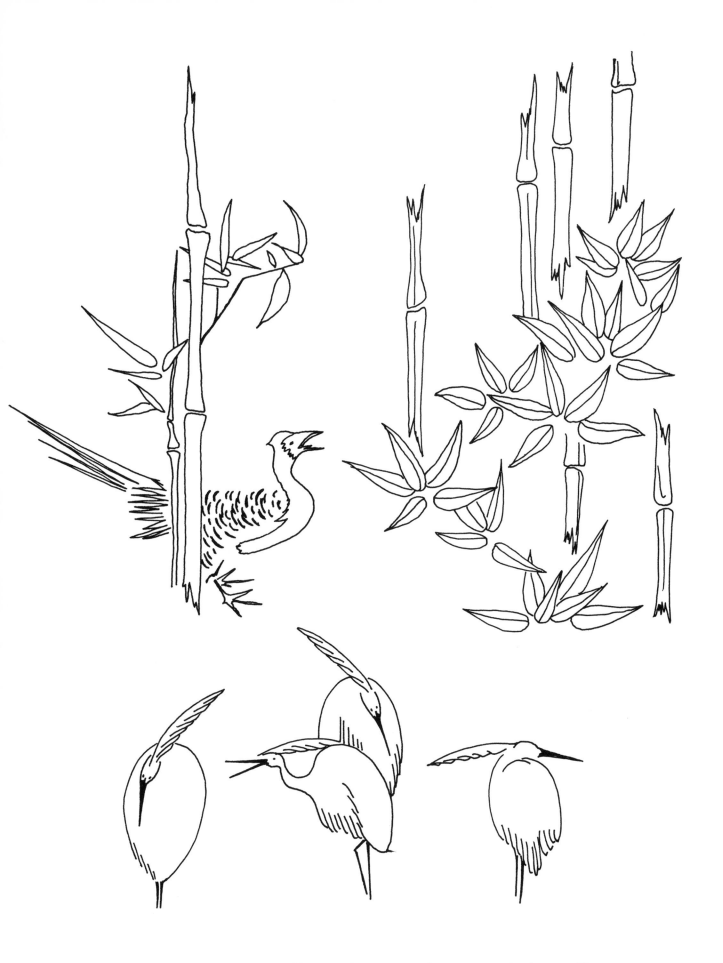

TOP LEFT: Pheasant and bamboo motif from a 20th-century textile. TOP RIGHT: Bamboo motif from a
19th-century ink drawing. BOTTOM: Heron motifs from a Nabeshima ceramic.

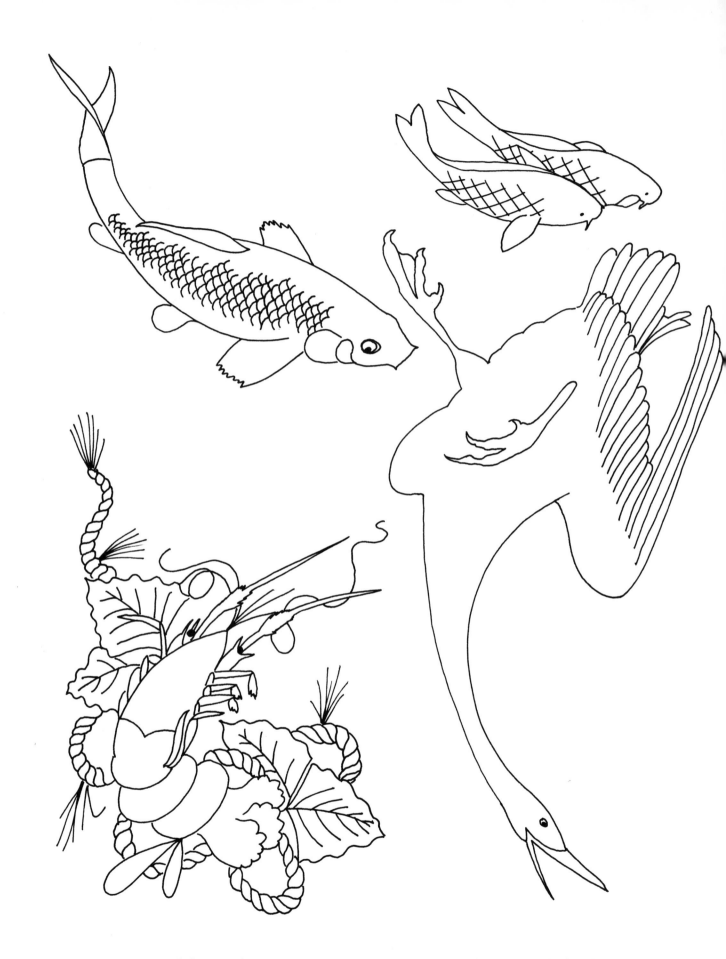

TOP: Carp motifs from a 19th-century print. BOTTOM LEFT: Crustacean (shrimp or crayfish?) and leaf motif from a 19th-century textile. RIGHT: Goose motif from an 18th-century ink drawing.

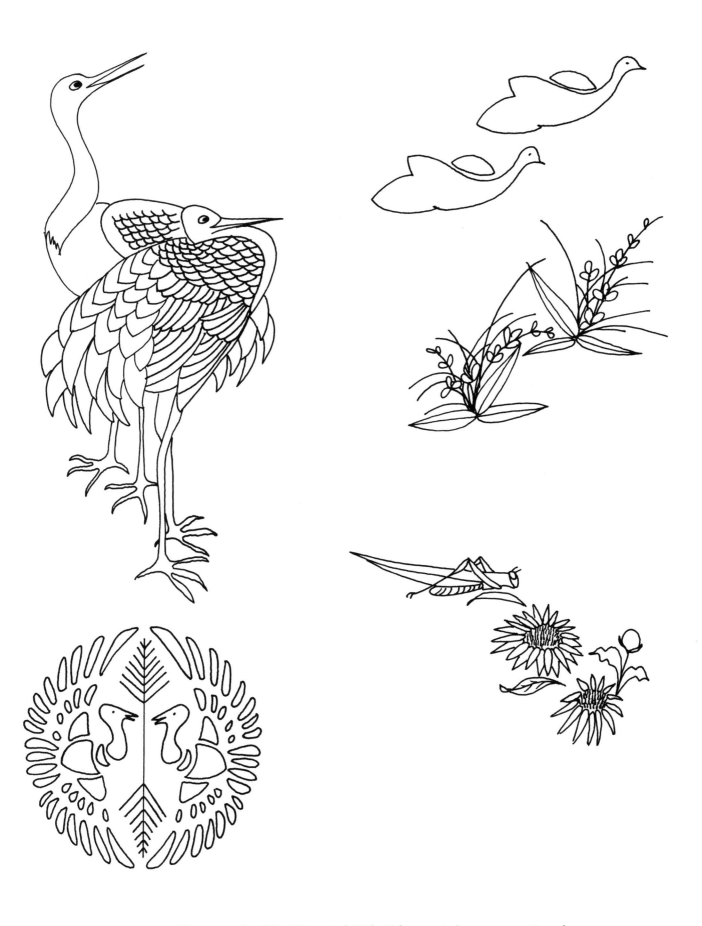

TOP LEFT: Crane motif from a textile of the Edo period (17th–18th centuries). TOP RIGHT: From lacquerware of the Edo period. BOTTOM LEFT: From a 19th-century textile. BOTTOM RIGHT: Grasshopper and floral motif from a Kutani porcelain dated 1650.

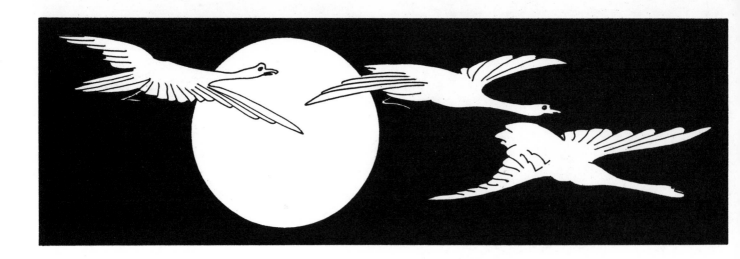

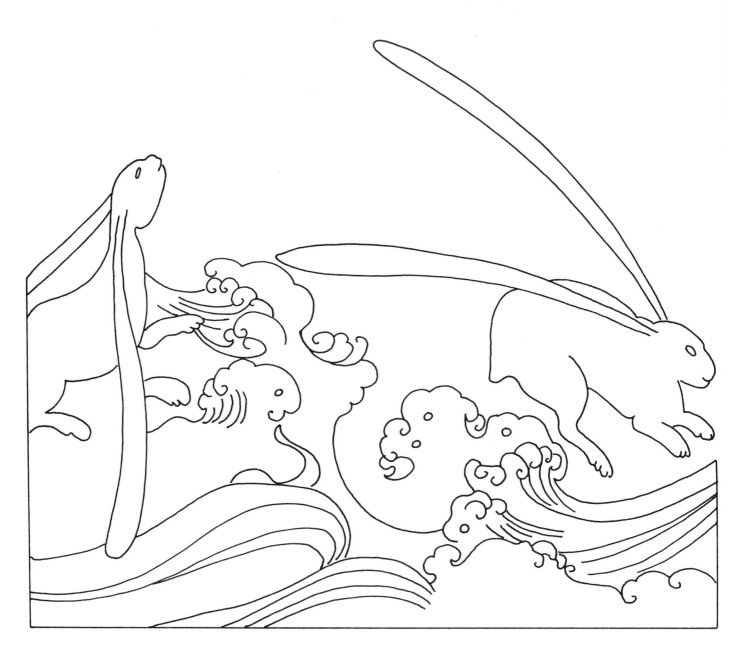

TOP: Geese flying against the moon, from a 19th-century print. BOTTOM: Rabbit and ocean wave motif from a 19th-century ceramic.

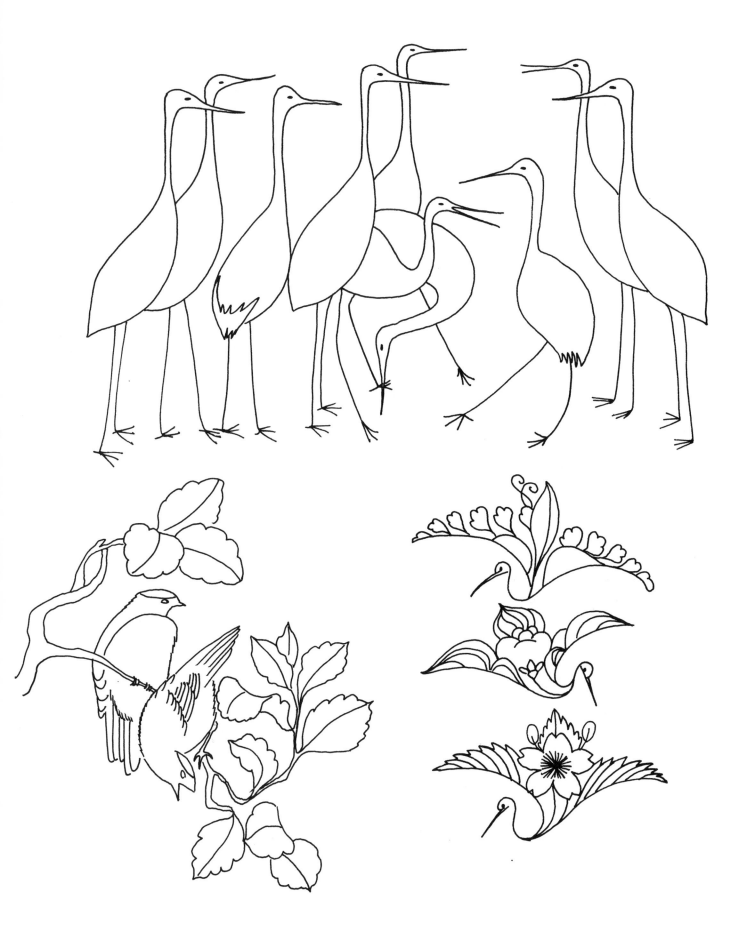

TOP: Group of cranes from lacquerware with mother-of-pearl inlay. BOTTOM LEFT: Bird and oak branch motif from a Nabeshima ceramic. BOTTOM RIGHT: Fanciful floral-based crane motifs by Hokusai.

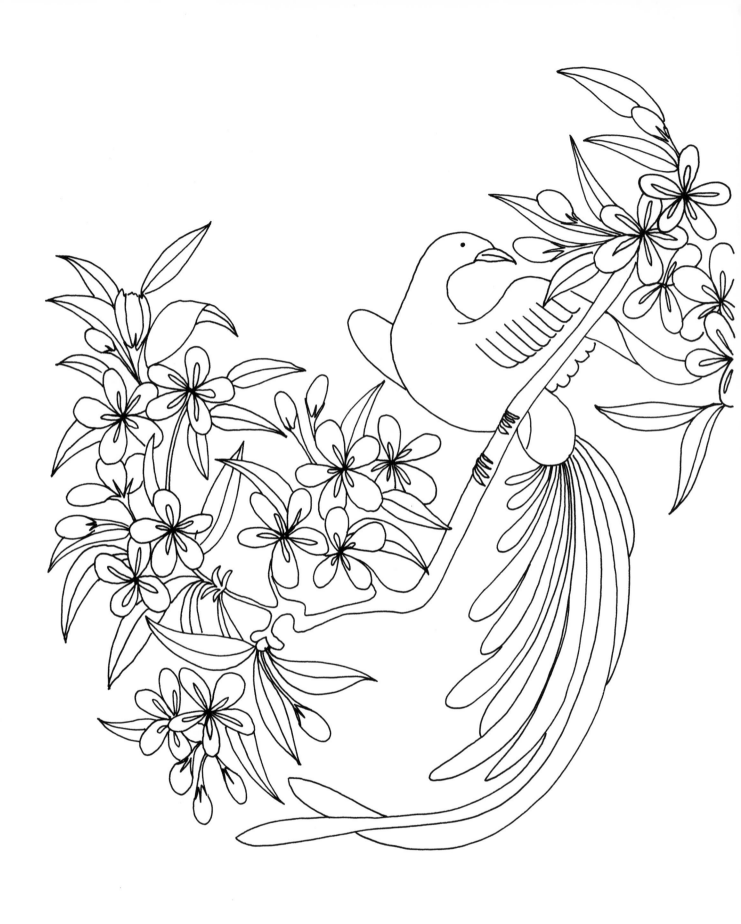

Bird and plum blossom motif from a 19th-century textile.

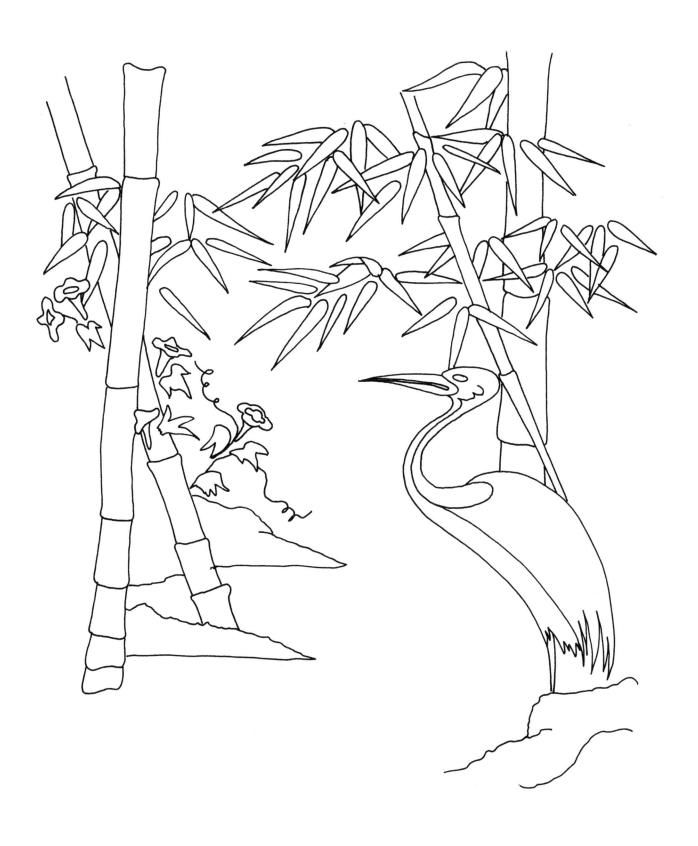

Bamboo, morning glory and crane motif from an early 18th-century painting.

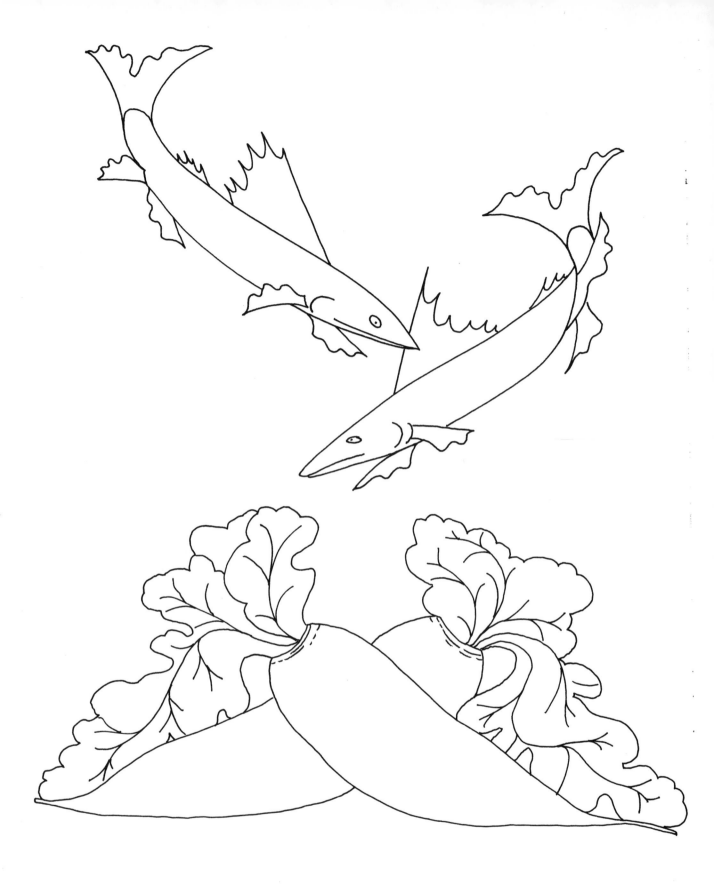

TOP: Fish design from a Kakiemon ceramic of the Edo period (17th–18th centuries). BOTTOM: Radish motif from a 19th-century carved wood panel.

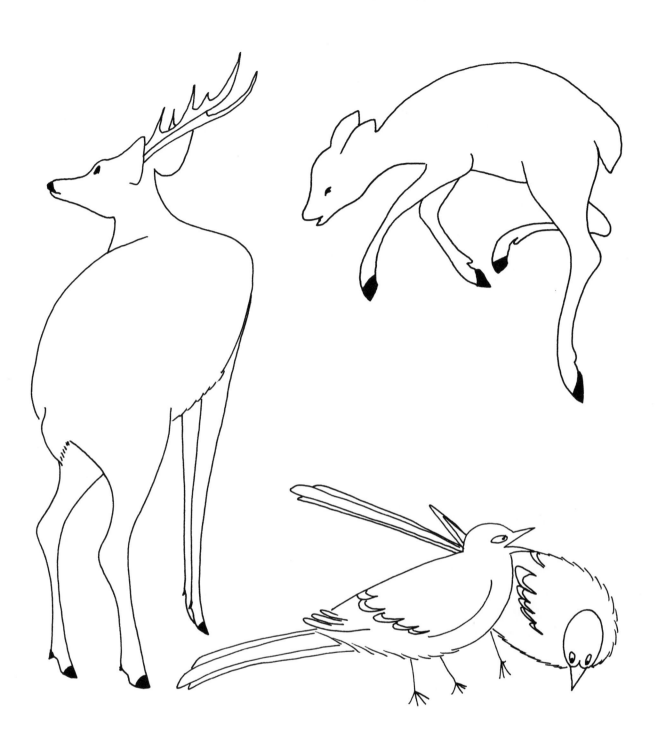

LEFT: Deer motif from an ink drawing dated 1815. TOP RIGHT: Fawn motif from a 20th-century embroidery.
BOTTOM RIGHT: Bird motif from a Nabeshima ceramic.

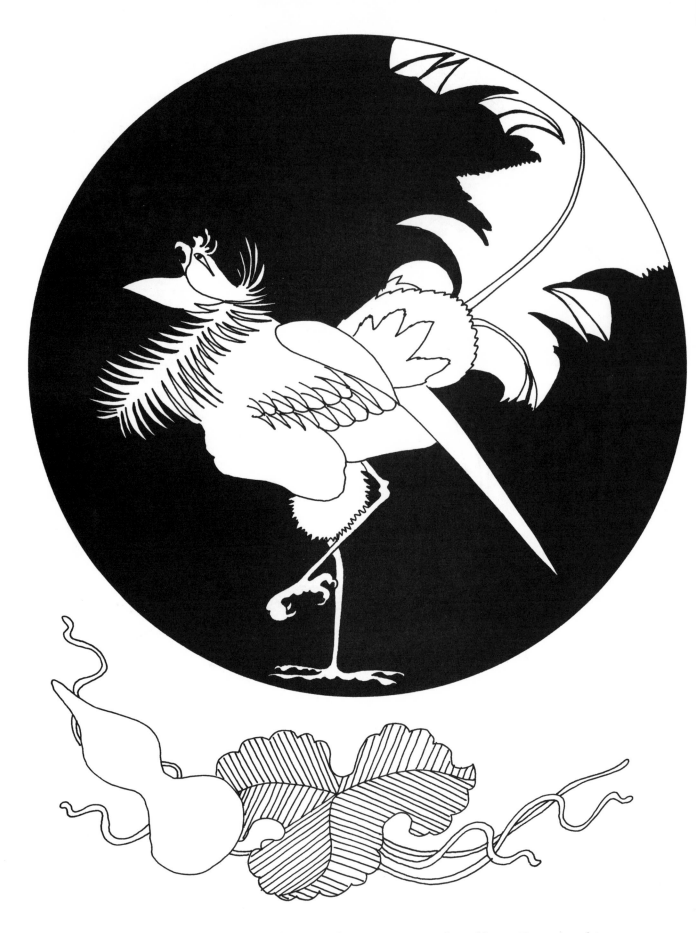

TOP: Pheasant motif from a Nabeshima porcelain. BOTTOM: Gourd motif from a Kutani porcelain of the Edo period (17th–18th centuries).

58

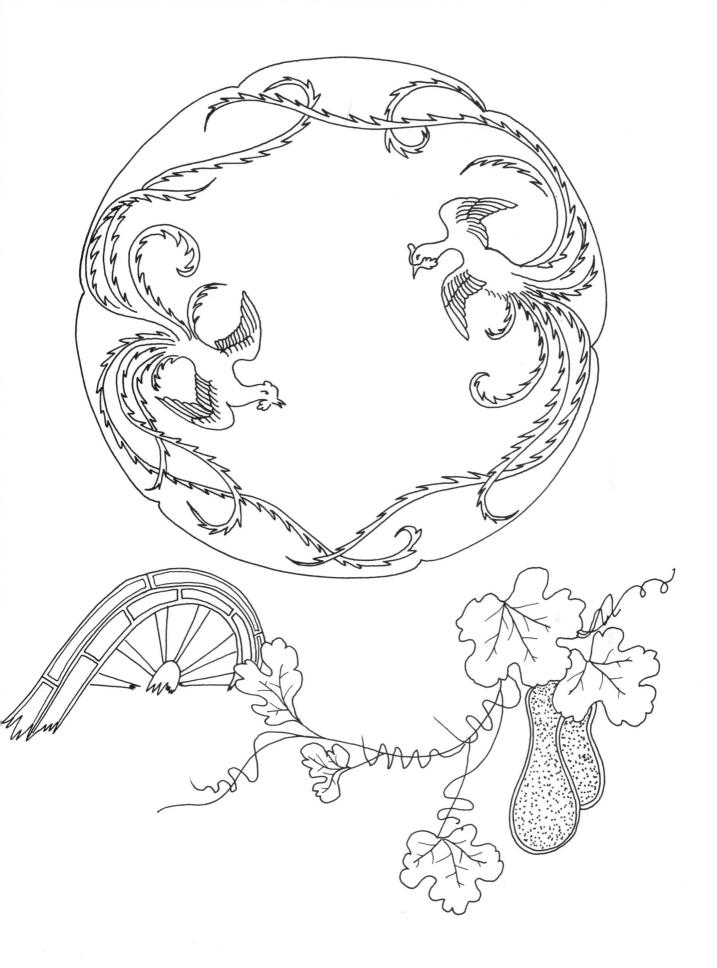

TOP: Rooster motif from an enameled Kakiemon ceramic. BOTTOM: Wheel and gourd motif from an 18th-century textile.

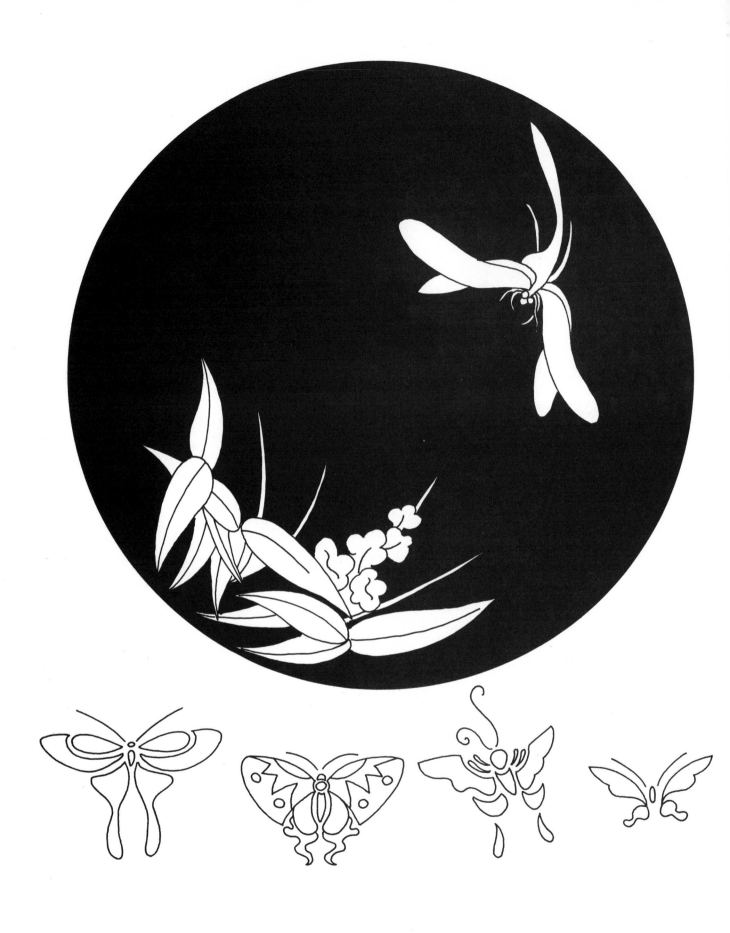

TOP: Dragonfly and arrowhead (*Sagittaria*, a water plant) motif from Momoyama period (late 16th–early 17th centuries) lacquerware. BOTTOM: Butterfly motifs from 18th-century stencil designs.

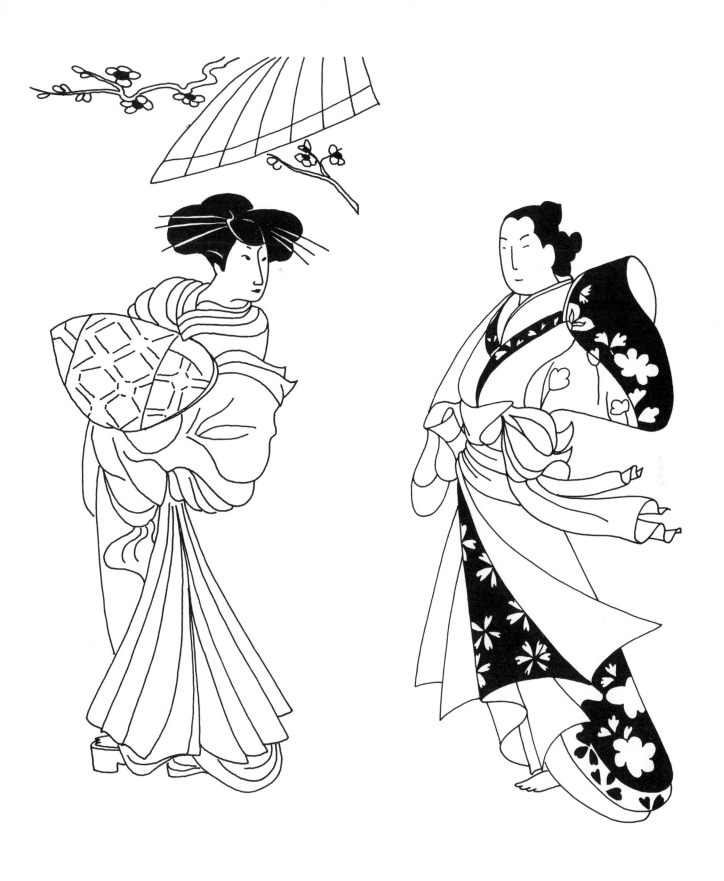

LEFT: From a woodcut by Torii Kiyonaga (1752–1815) dated 1779. RIGHT: From an early 19th-century ink drawing.

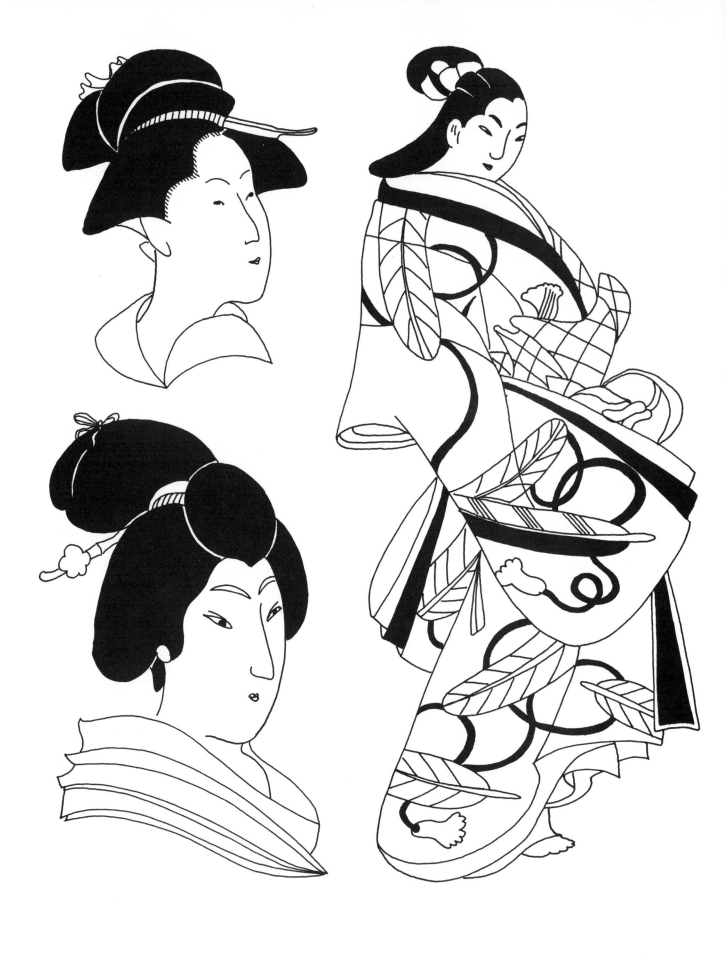

TOP LEFT: From an early 18th-century woodcut. BOTTOM LEFT: From a 20th-century textile. RIGHT: From an 18th-century print.

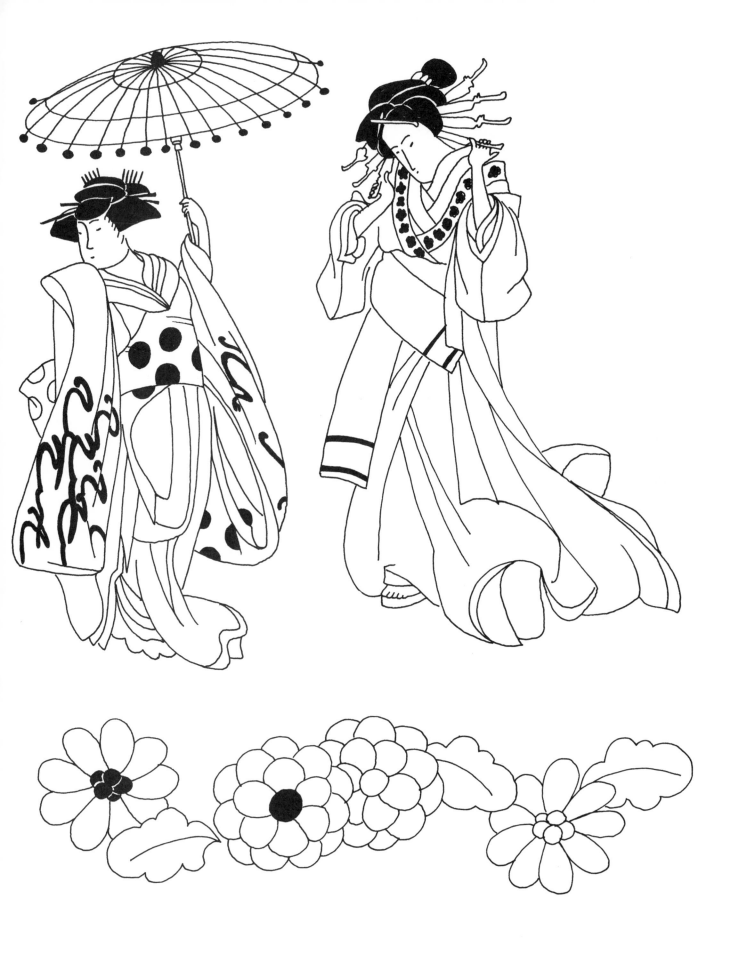

TOP: From a 19th-century ink drawing. BOTTOM: Chrysanthemum motifs from a 19th-century textile.

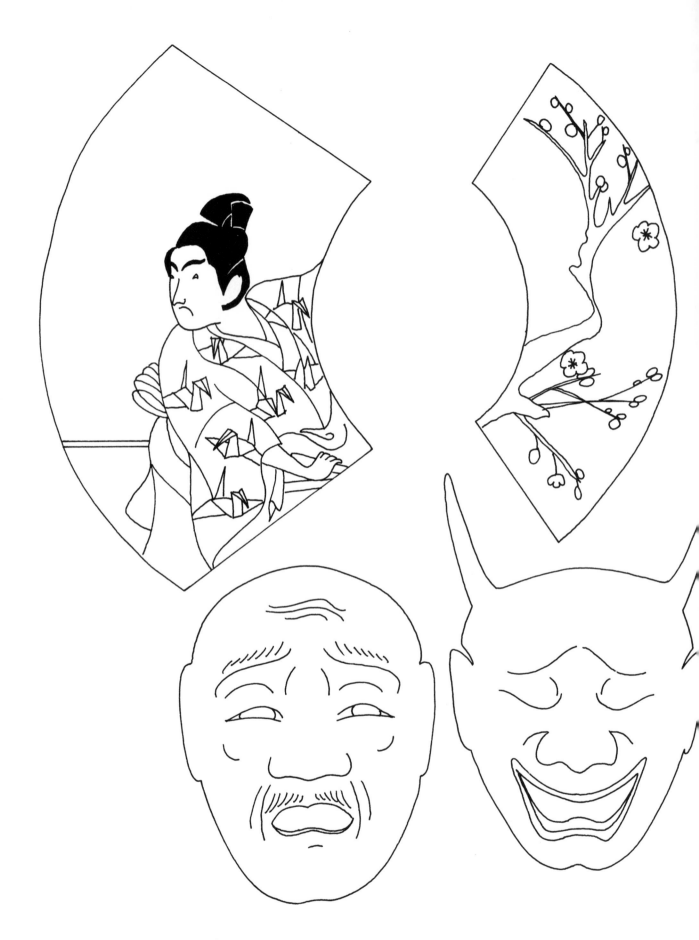

TOP LEFT: From a 19th-century No fan. TOP RIGHT: Cherry or plum blossom motif from an 18th-century silk fan. BOTTOM: Wooden No masks of the 19th century.

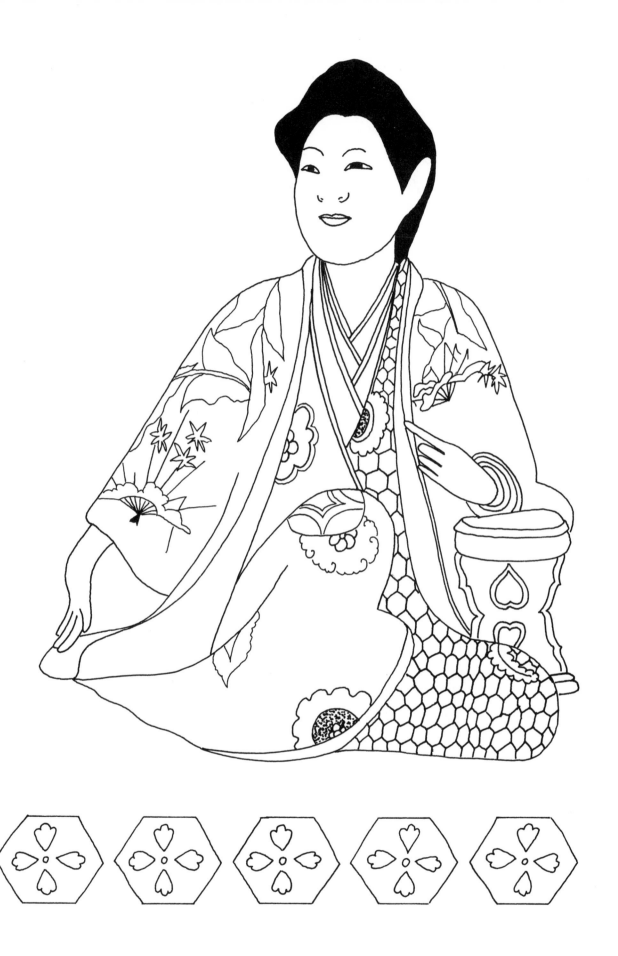

TOP: From an Arita porcelain of the Edo period (late 17th century). BOTTOM: From a 19th-century textile.

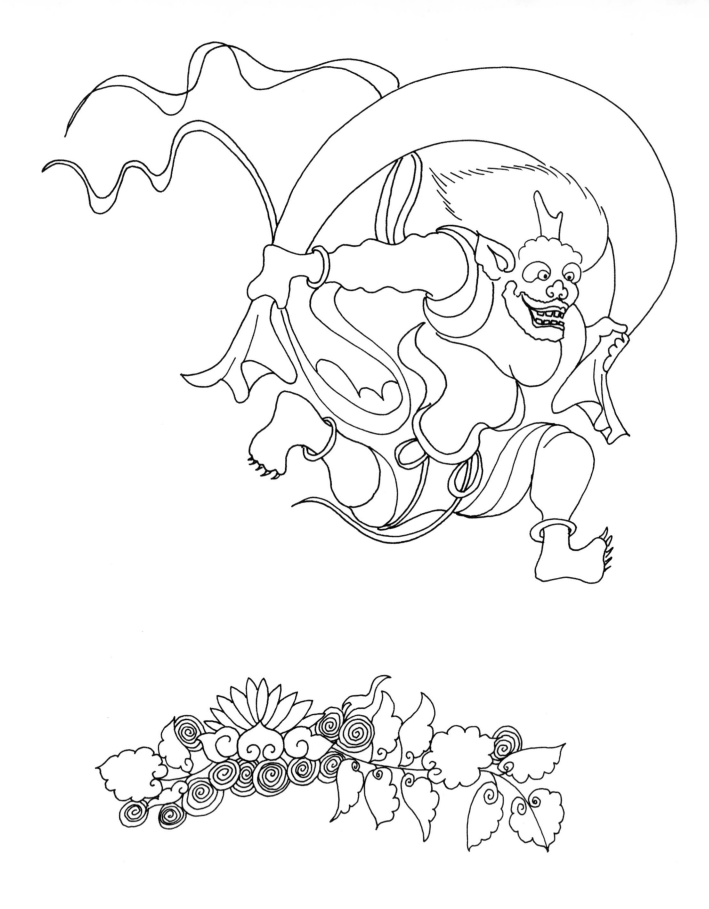

TOP: Thunder or wind god from a 17th-century screen. BOTTOM: From an 18th-century Nabeshima ceramic.

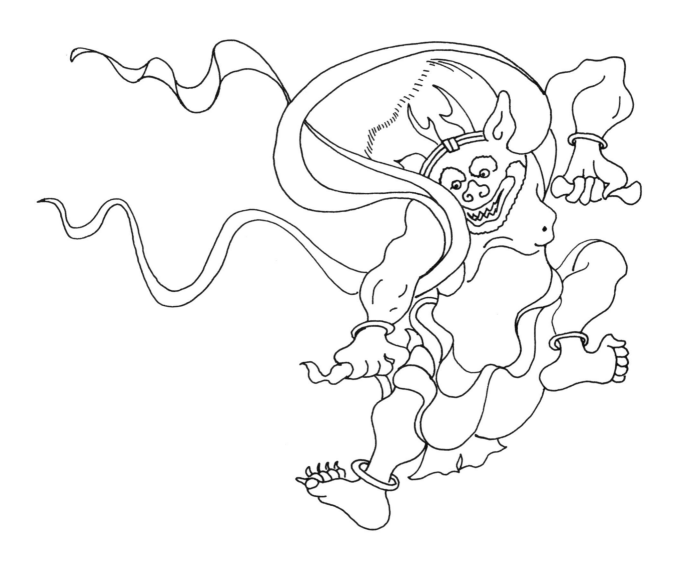

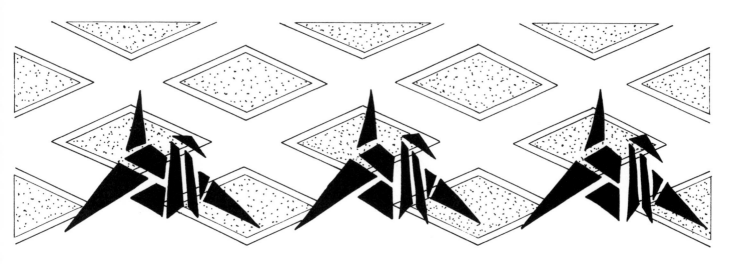

TOP: Thunder or wind god from a 17th-century screen. BOTTOM: Origami-style bird (crane?) motifs on a 20th-century textile design.

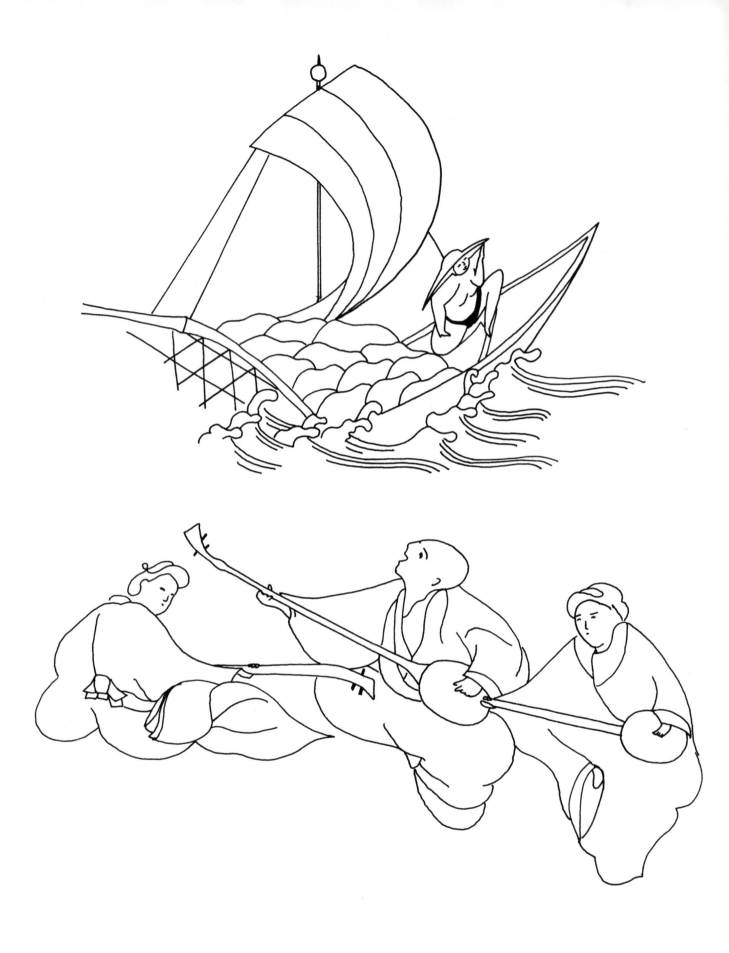

TOP: From an 18th-century ceramic. BOTTOM: From a 19th-century textile.

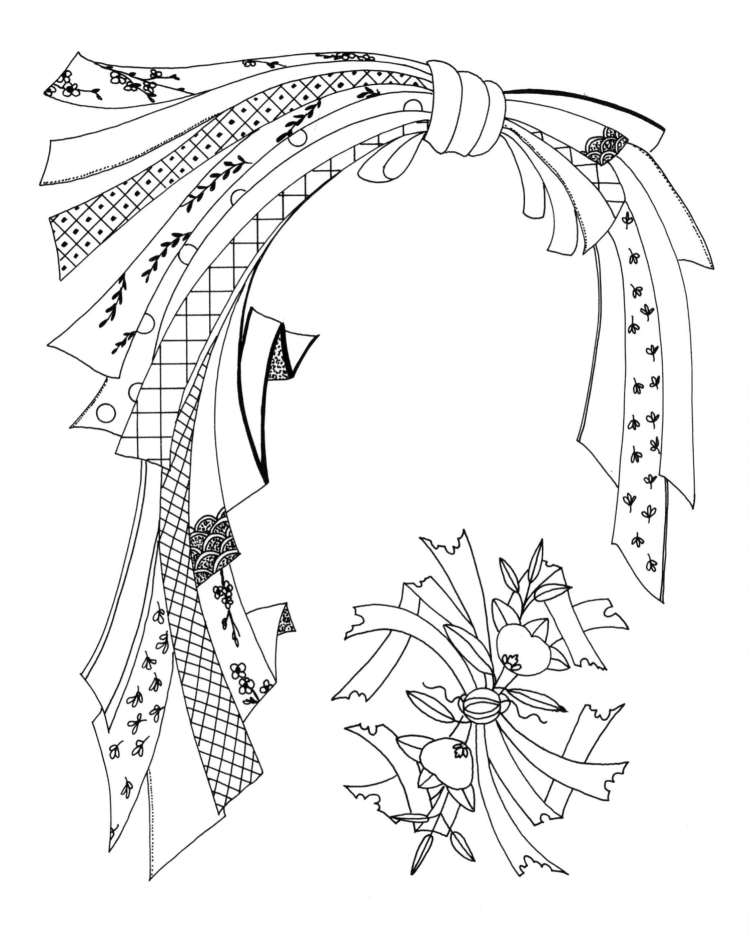

TOP: *Noshi*, a traditional symbol of humility, originally a bundle of dried strips of a shellfish. BOTTOM: *Noshi* with mandarin oranges, from a 19th-century textile.

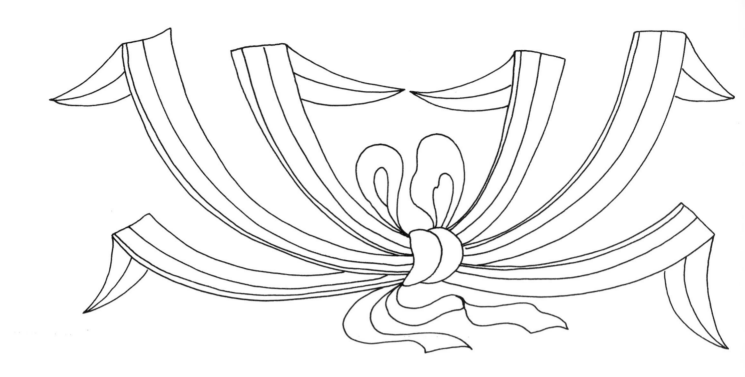

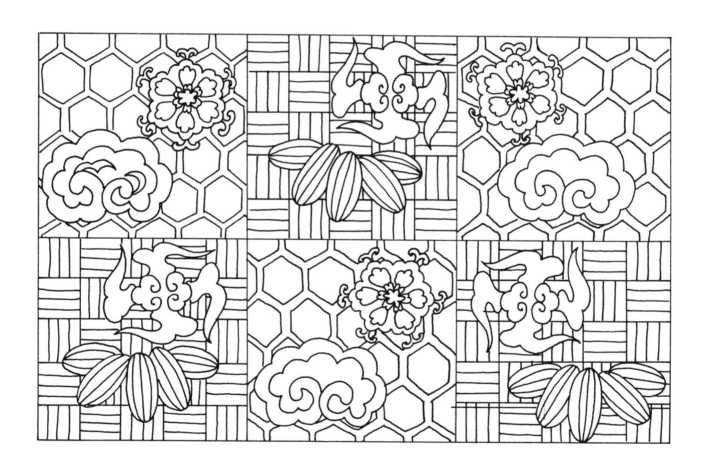

TOP: From a 19th-century textile. BOTTOM: From an 18th-century textile.

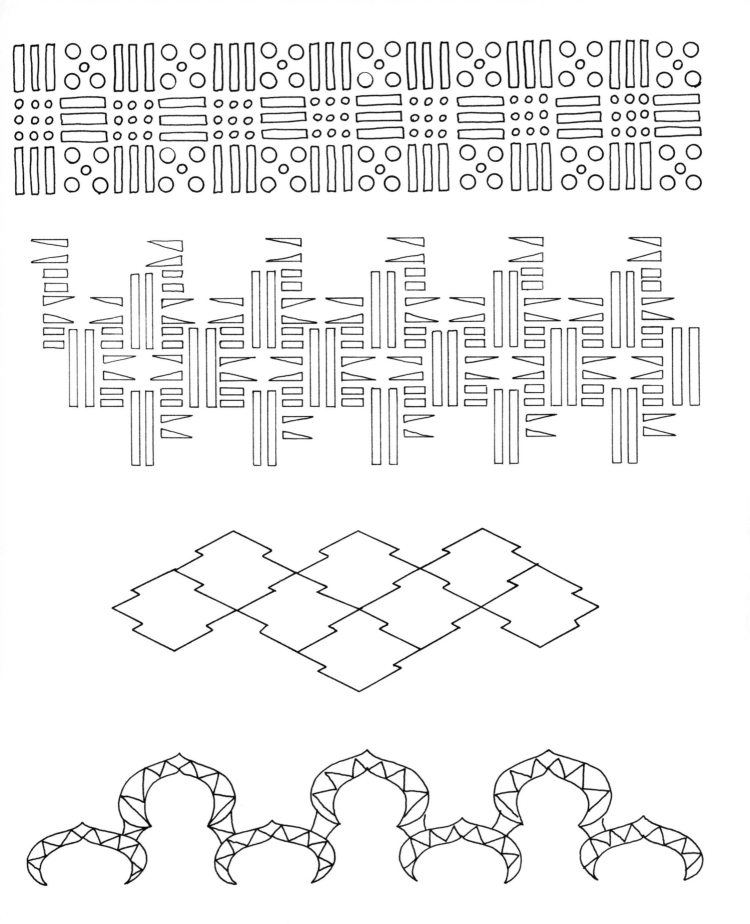

TOP TWO BANDS: Geometric patterns from 19th-century textiles. THIRD BAND: From a late 16th-century textile. BOTTOM BAND: From an Imari ceramic.

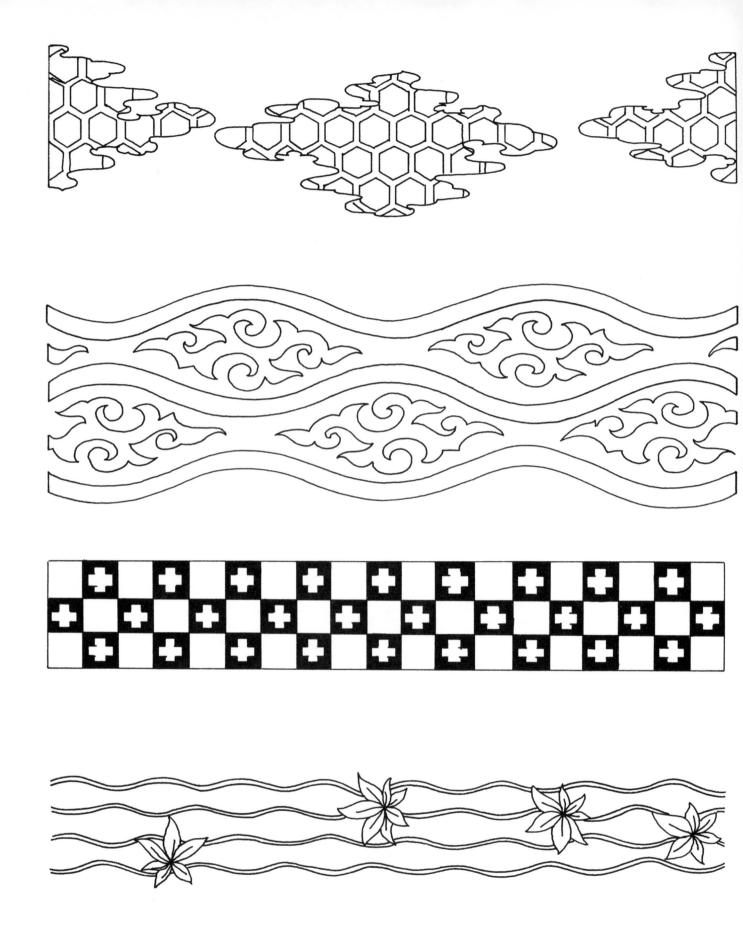

TOP BAND: From a 16th-century silk embroidery. REMAINING BANDS: From 19th-century textiles.

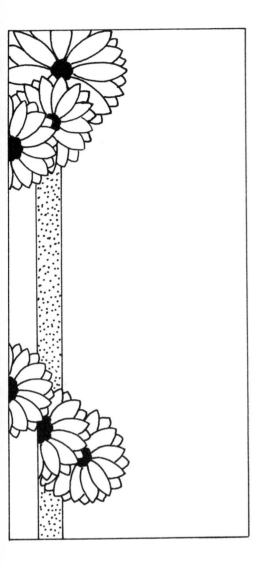
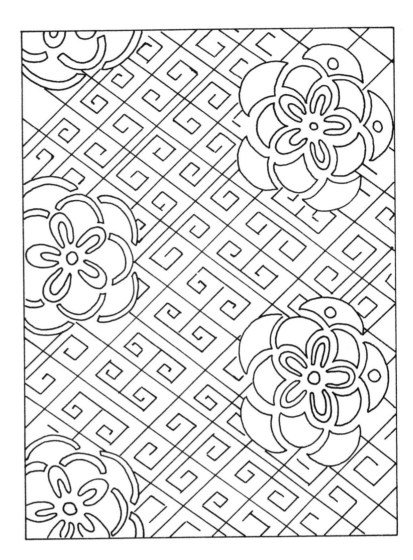

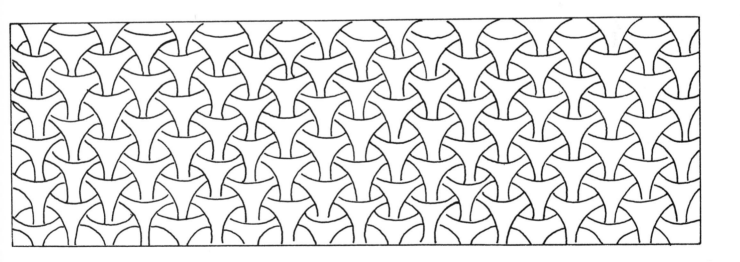

TOP LEFT: 19th-century textile design with chrysanthemum motif. TOP RIGHT: 20th-century textile design with floral motif over a geometric pattern. BOTTOM: Textile pattern of the Edo period (17th–18th centuries).

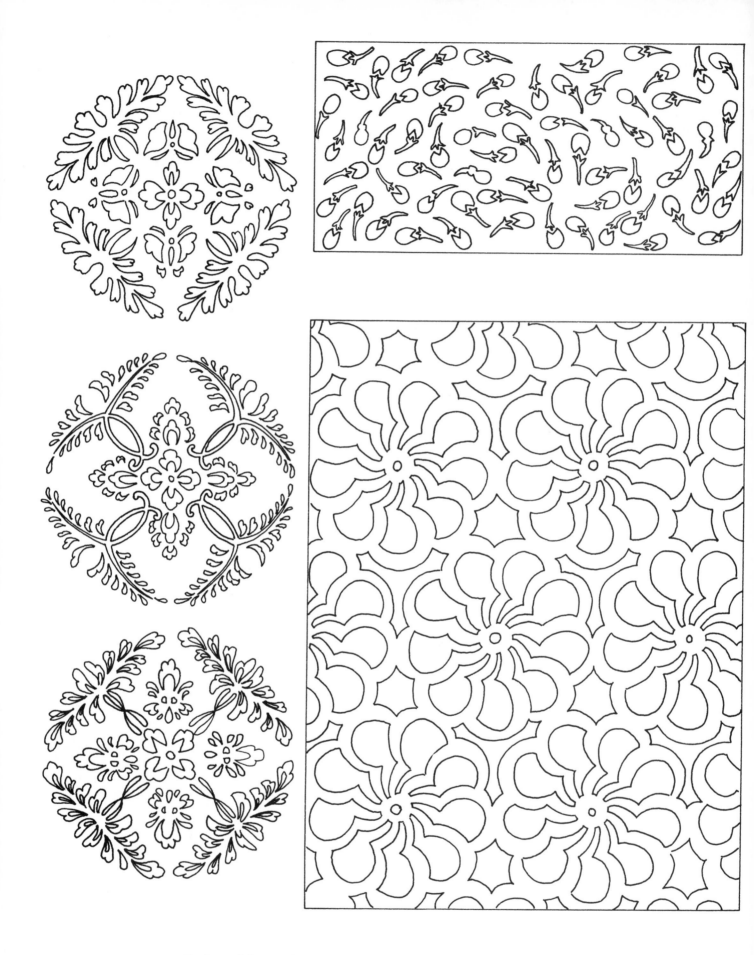

LEFT: Floral motifs from 19th-century textiles. TOP RIGHT: Eggplant motifs from a textile design.
BOTTOM RIGHT: Repeating pattern from a 19th-century textile.

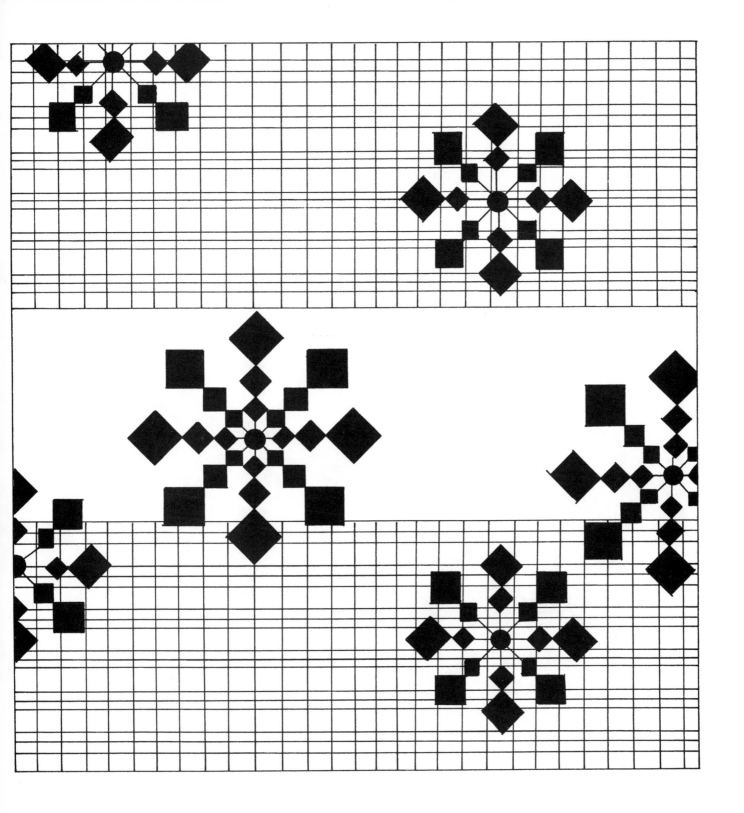

Geometric pattern from a textile of the Edo period (17th–18th centuries).

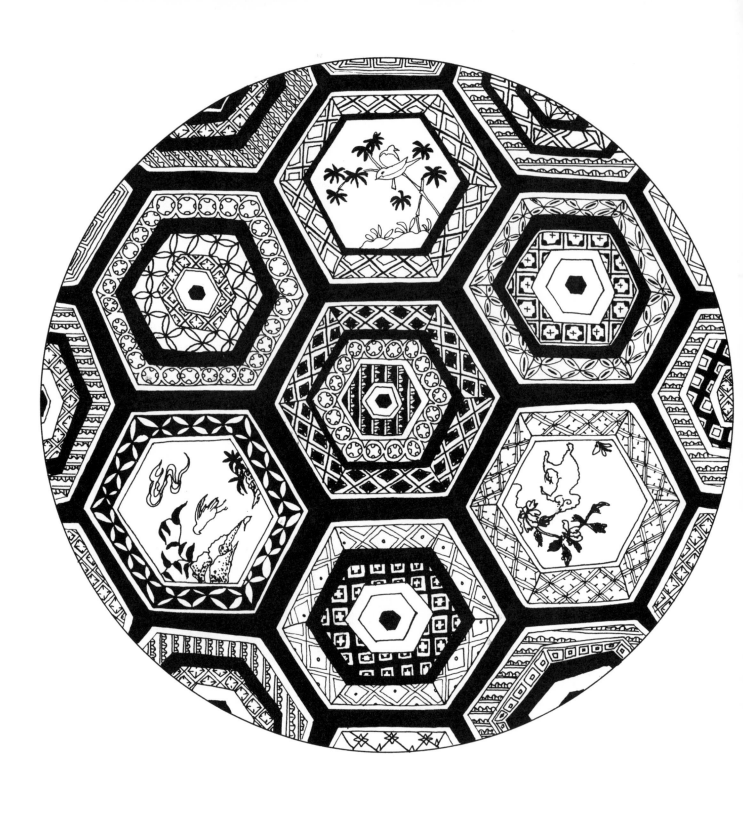

From a 17th-century Kutani porcelain.

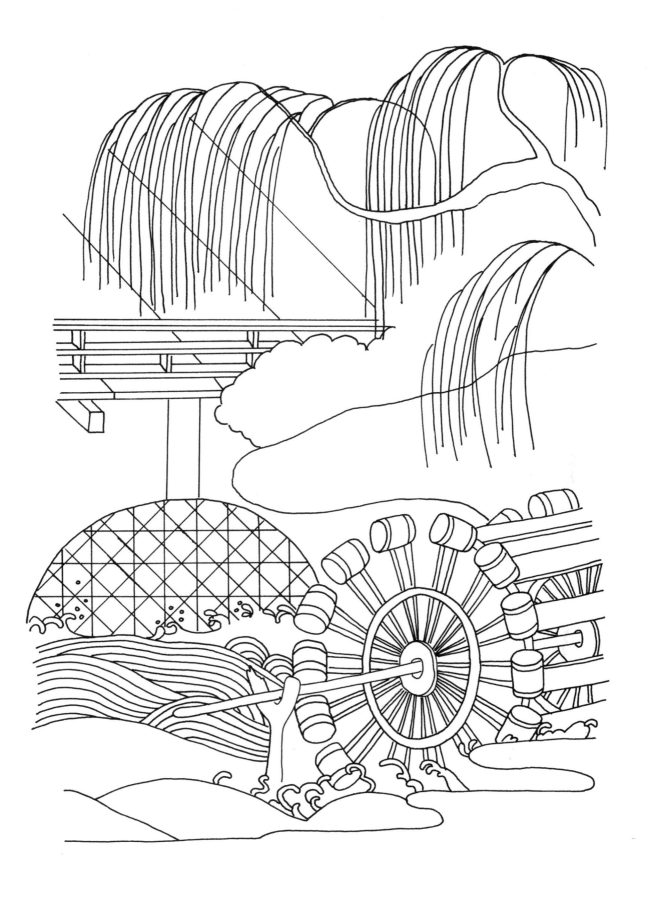

Details from a painted screen of the 17th century depicting a bridge in a Kyoto suburb.

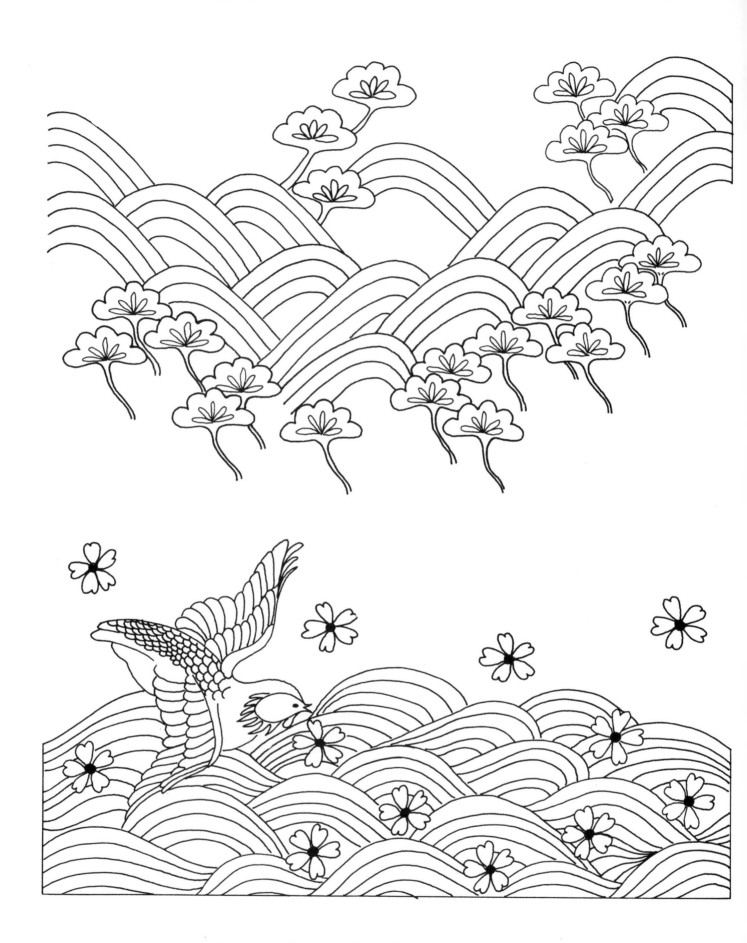

TOP: Pine grove and wave motif from a late 17th-century textile. BOTTOM: Bird, plum blossom and wave motif from a 19th-century textile.

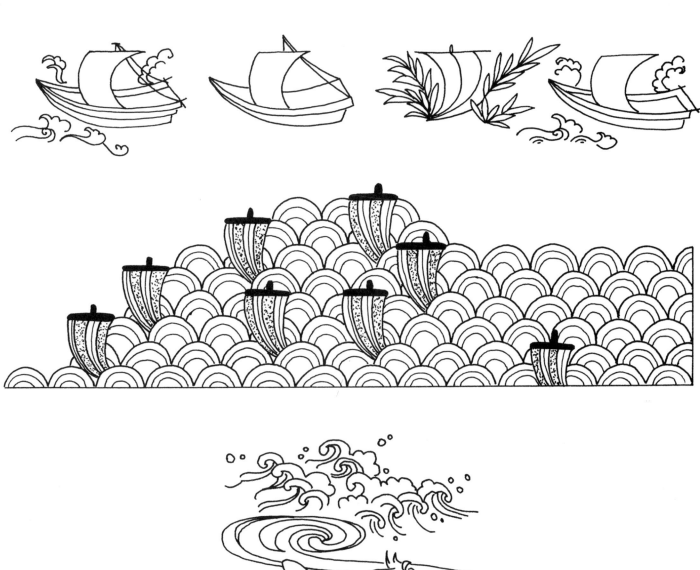

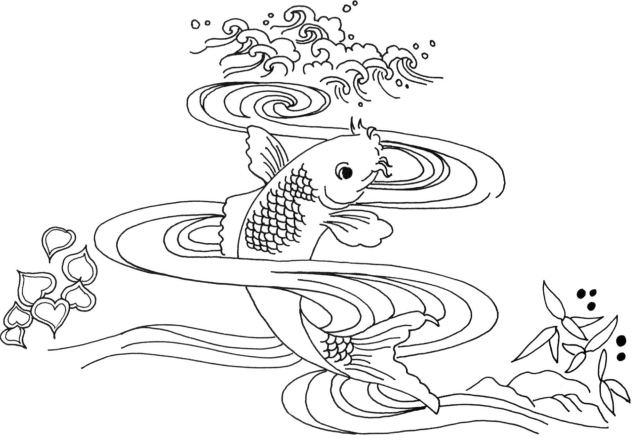

TOP: Boat motifs from 19th-century textiles. CENTER: Sailboat and waves motif from a late 17th-century No robe. BOTTOM: Swimming carp motif from a 19th-century ceramic.

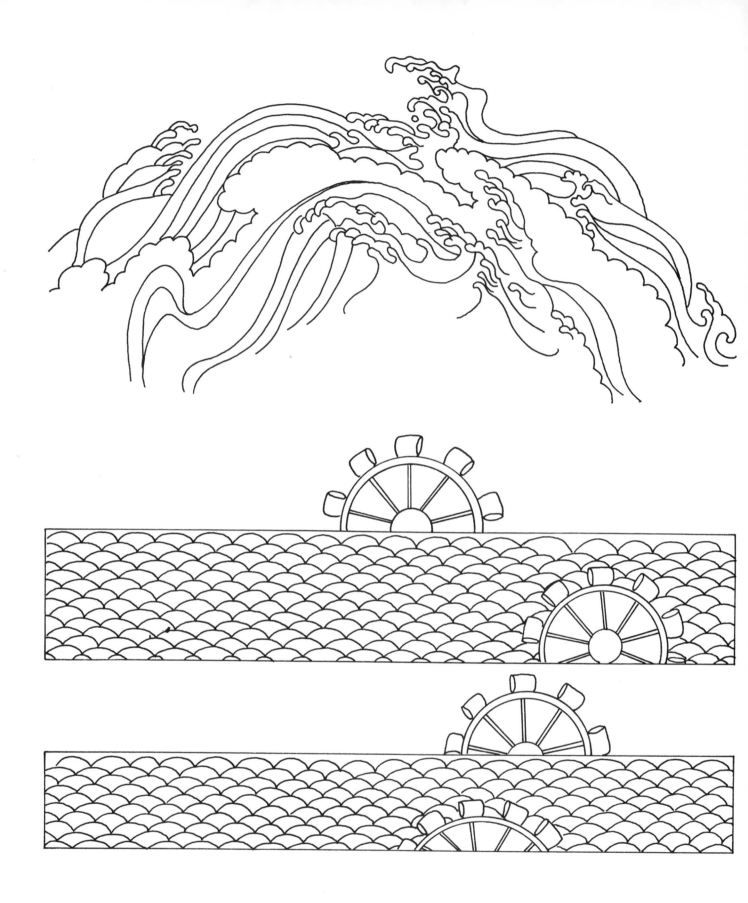

TOP: Wave motif from a 19th-century silk fan. BOTTOM: Waterwheel and waves motif
from a 19th-century Nabeshima ceramic.

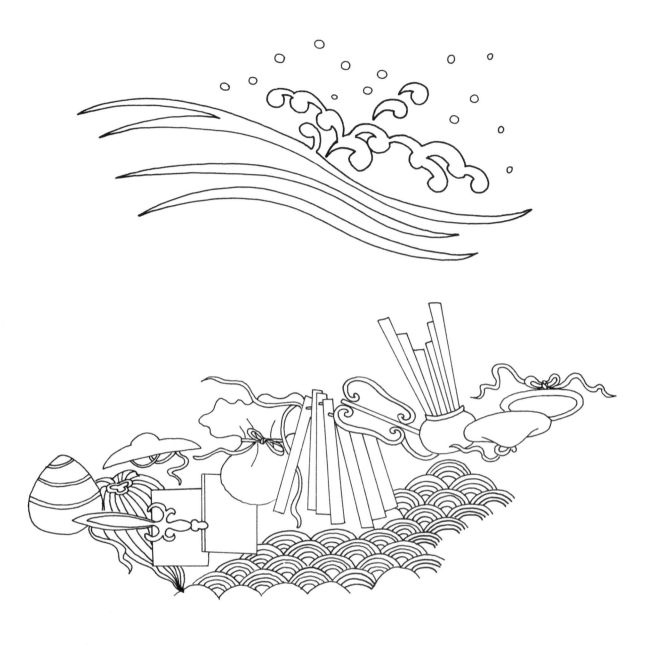

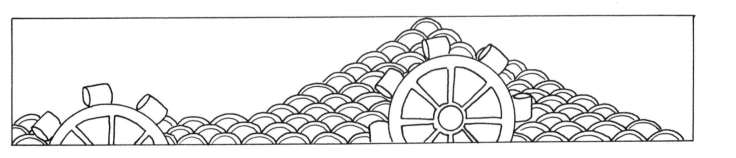

TOP: Wave motif from 19th-century lacquerware. CENTER: Ocean waves and treasures design from a 19th-century porcelain. BOTTOM: Waterwheel and waves motif from an 18th-century ceramic.

81

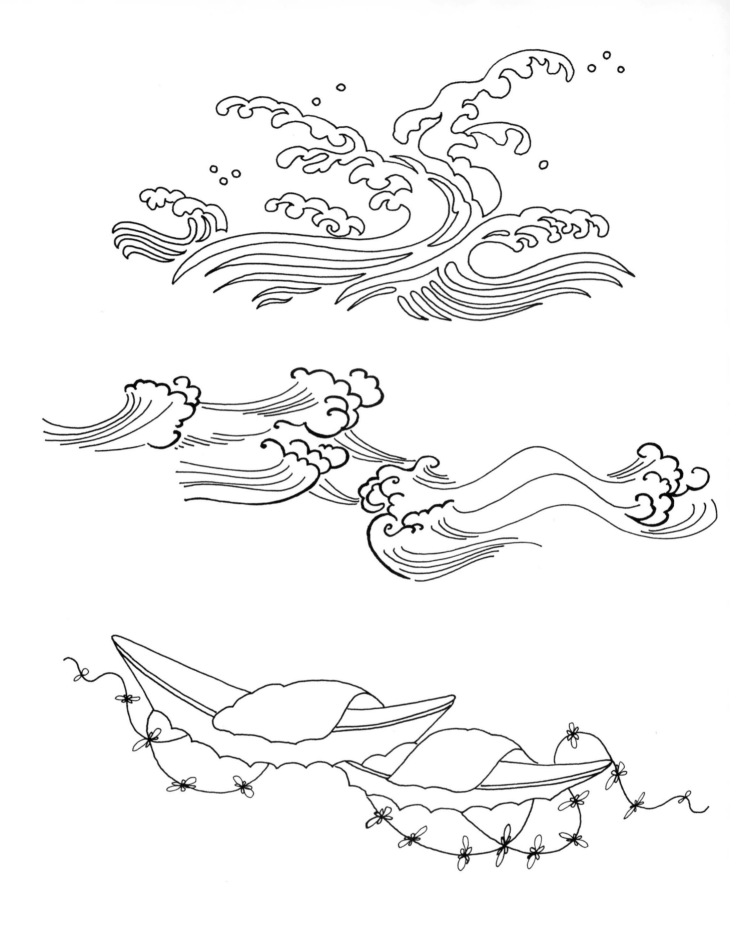

TOP: Wave motif from a 17th-century Ninsei ceramic. CENTER: Wave motif from a screen of the Muromachi period (14th–16th centuries). BOTTOM: Boat motif from a 19th-century textile.

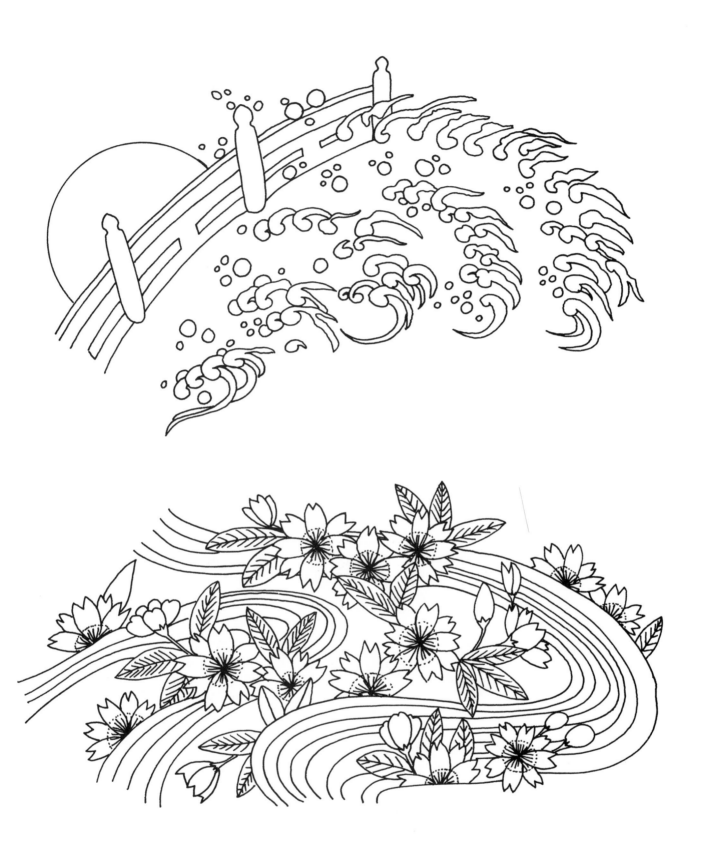

TOP: From a 19th-century silk fan. BOTTOM: Plum blossom and waves motif from a 19th-century textile.

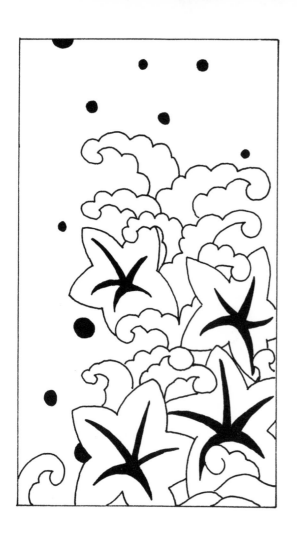

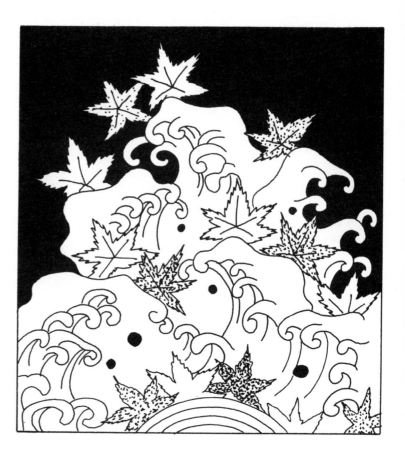

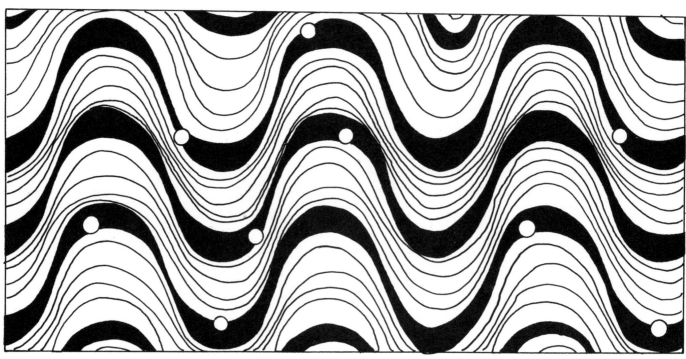

TOP: Maple leaf and wave motifs. TOP LEFT: From a 19th-century textile. TOP RIGHT: From a 19th-century ceramic. BOTTOM: Wave motif from a 19th-century textile.

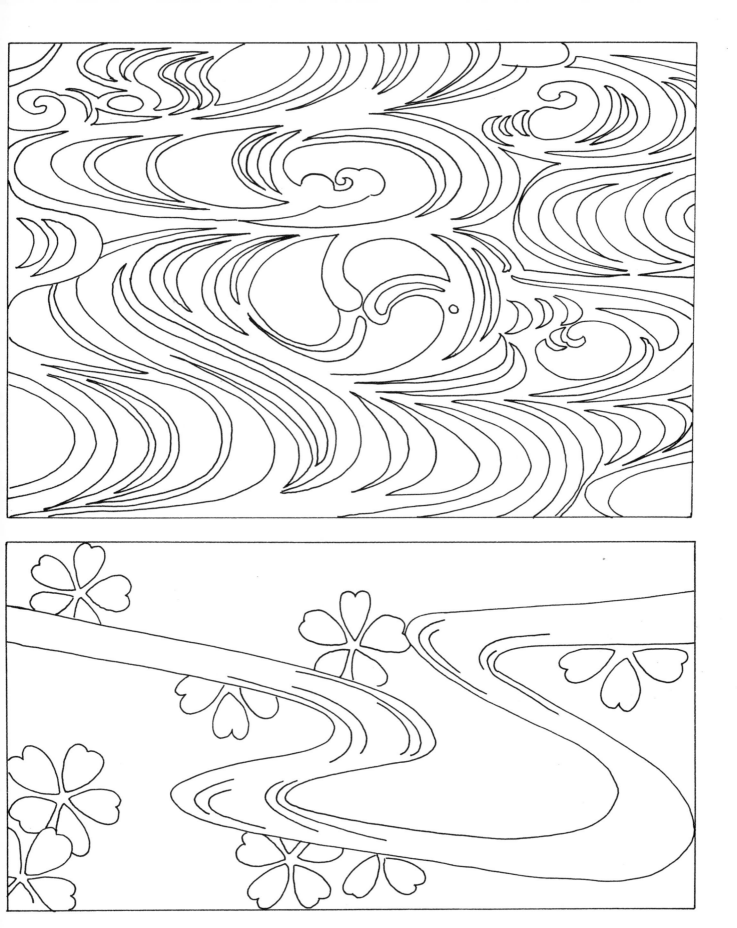

From 19th-century ink drawings.

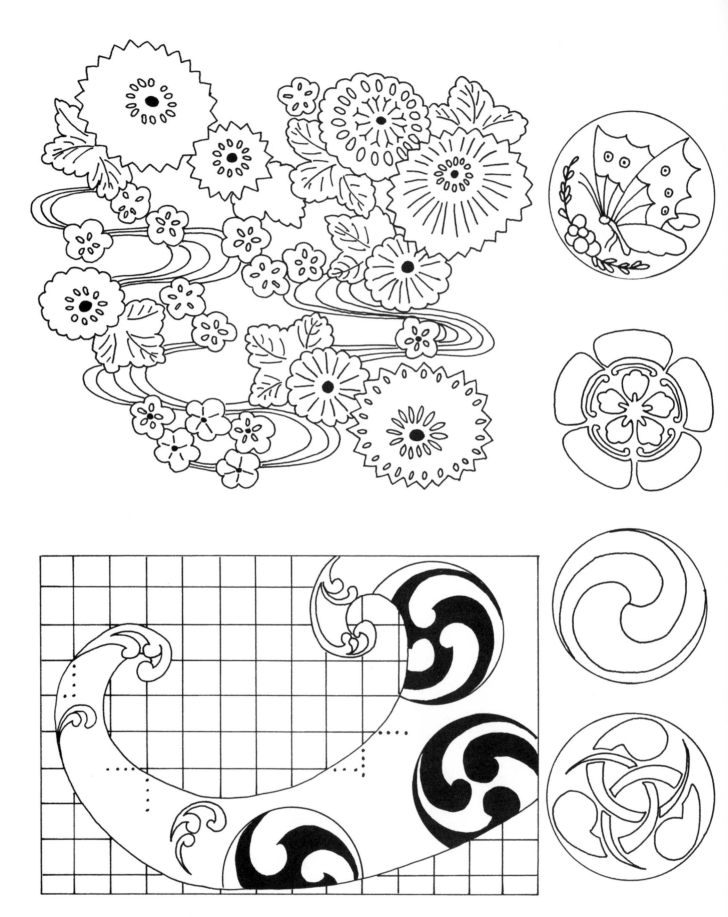

TOP LEFT: Floral and wave motif from a 19th-century textile. BOTTOM LEFT: Stylized wave and *tomoe* ("large commas") motif on a square grid pattern, from a 19th-century textile. RIGHT, TOP TO BOTTOM: Butterfly crest from a 19th-century textile; floral motif from a 19th-century wood carving; *tomoe* motif from a 13th-century ceramic; *tomoe* motif from an 18th-century textile.

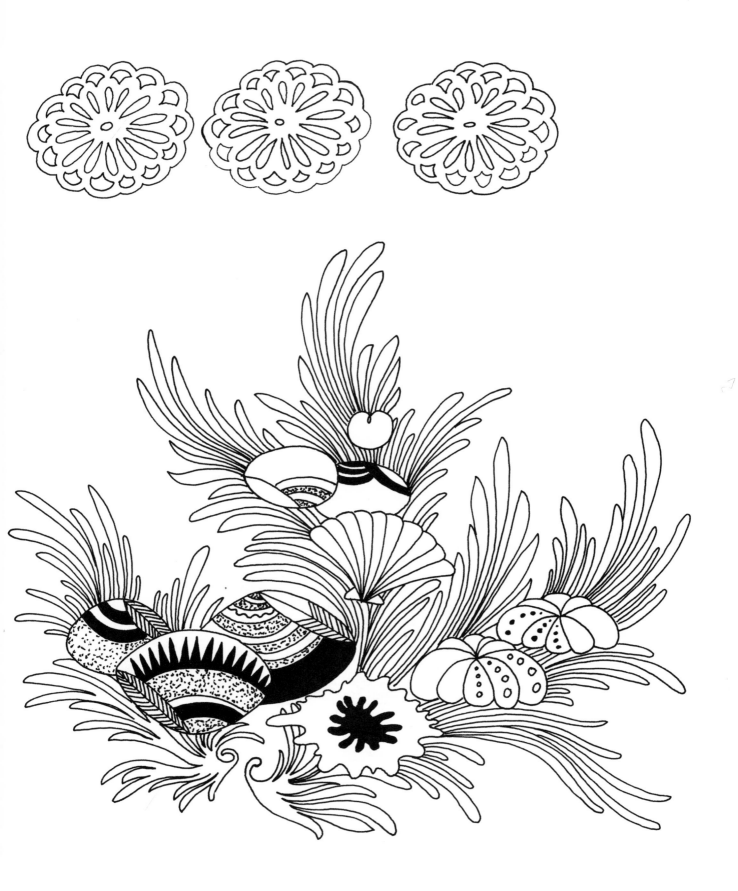

TOP: Floral motif from a 19th-century textile. BOTTOM: Seaweed and seashell motif from a Nabeshima ceramic.

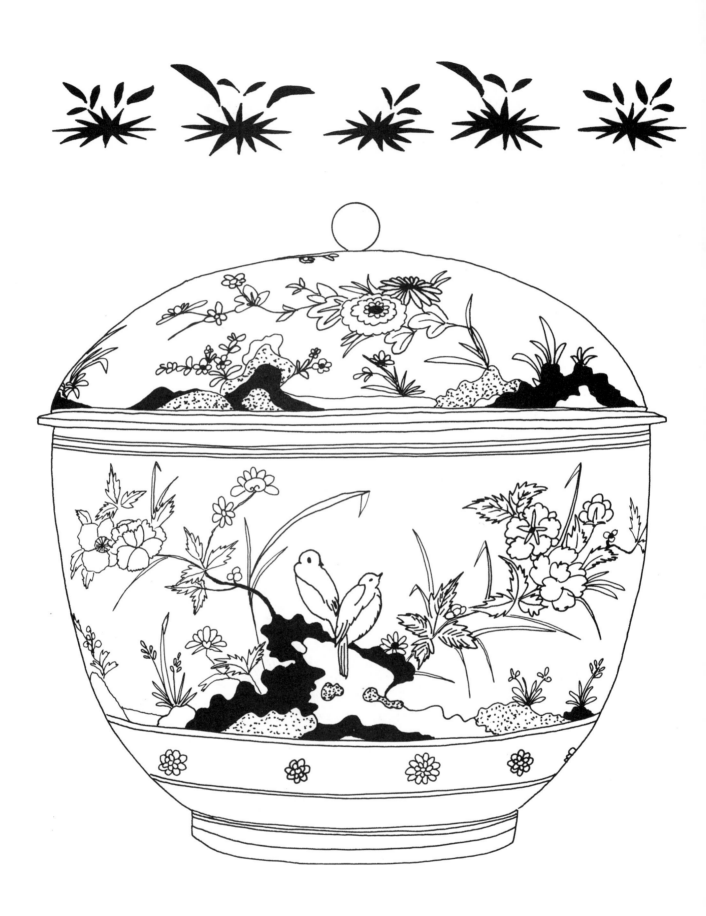

TOP: Stylized chrysanthemum motif from a 19th-century ceramic. BOTTOM: From a Kakiemon ceramic.

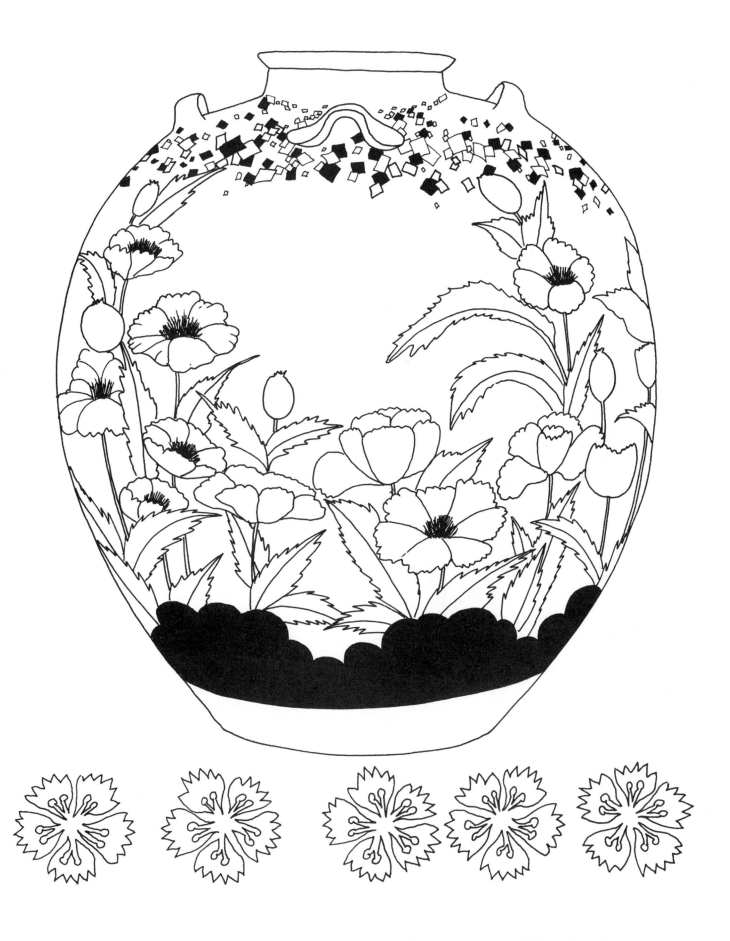

TOP: Poppy motif from a porcelain of the Edo period (17th–18th centuries). BOTTOM: Wild pink motifs from a 19th-century textile.

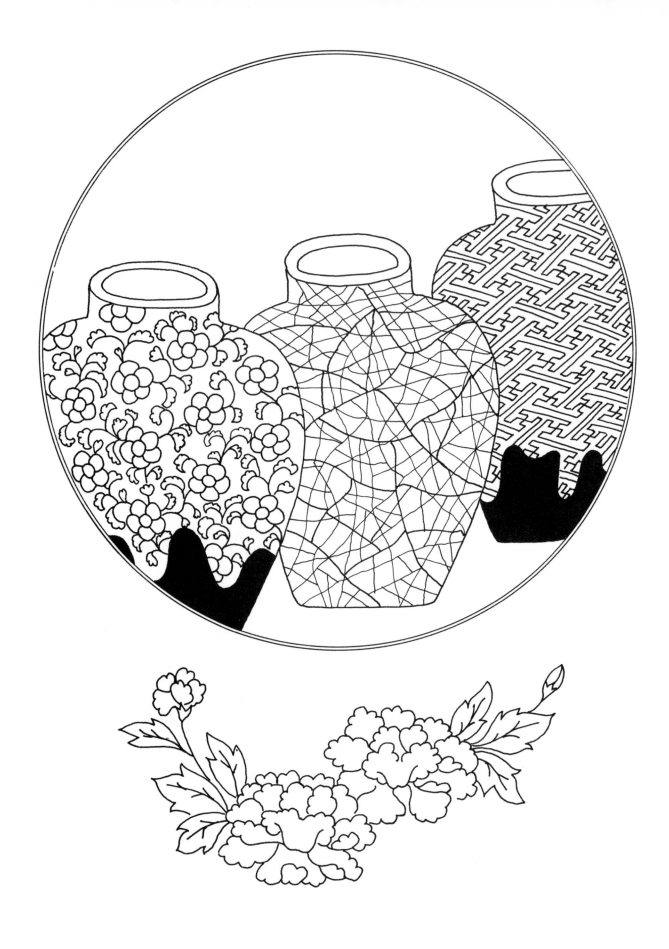

TOP: Designs from late 18th-century Nabeshima porcelains. BOTTOM: Peony motif from a 20th-century textile.